Boris Friedewald

Bauhaus

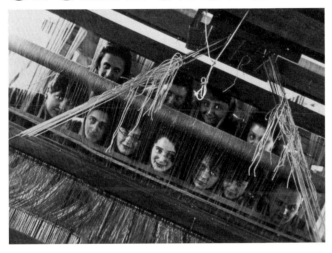

Prestel

Munich · London · New York

Context

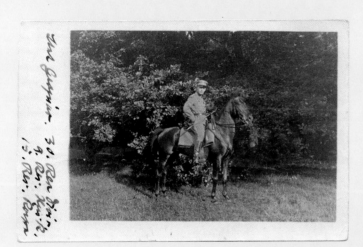

"The main principle of the Bauhaus is the idea of a new unity; a gathering of art, styles, and appearances that forms an indivisible unit. A unit that is complete within its self and that generates its meaning only through animated life."

Walter Gropius, 1925

Modernism's Lines of Development

The Bauhaus was unique, avant-garde, and pursued a path that led purposefully toward Modernism. Its members practiced an anti-academic education, had a concept of utopia and sought the mankind of the future, for whom they wanted to design according to need. Before the Bauhaus there had admittedly already been various reformist approaches to, and ideas on, education and art. But the Bauhaus was unique because it concentrated these aspirations and made them into reality.

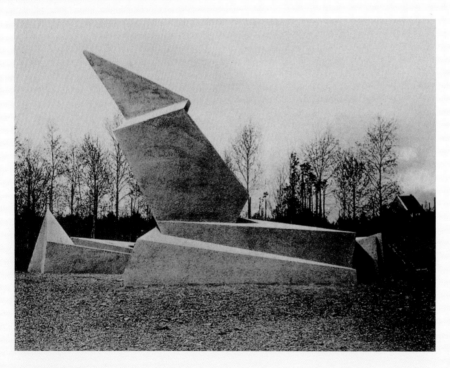

This memorial to the workers murdered in the Kapp Putsch of March 1920, built in 1922 to a design by Walter Gropius at the Cemetery of Honor in Weimar, is distinguished by its Expressionist language of forms.

The Expressionist Bauhaus

Many pieces of work by the students, but also by the masters, from the first years of the Bauhaus speak an Expressionist language and continue an artistic direction that came into being before the First World War. These works are often crystalline in form, have strong colors, and spiritual associations. For Gropius, Expressionism was at first the expression of the beginning of a new world view. It was the later preoccupation with Constructivism, the appointment of László Moholy-Nagy, and Gropius' motto "Art and technology: a new unity" of 1923 that caused the disappearance of Expressionism at the Bauhaus.

Gropius' Creed

In the early days of the Bauhaus, Walter Gropius himself referred to artists and groups in whose lines of development he saw the Bauhaus positioned. Here are just a few of the names he mentions:

--→ **The English Critic John Ruskin,** who saw the increasing industrialization of the second half of the 19th century as a threat. He supported a return to medieval working methods and favored Gothic ornament.

--→ **The Multitalented William Morris,** a follower of Ruskin, for whom the arts—as for Ruskin—are based on the crafts. Morris, a socialist, wanted to create "from the people for the people." The Arts and Crafts Movement, which he founded, strongly influenced the reforms in the crafts in the Art Nouveau period (known as Jugendstil period in Germany).

The Worst Insult at the Bauhaus…

was "academic"—for this is what its members wished to overcome. The traditional academies not only did not distinguish between high and applied art. They had long before dissolved the link between the fine arts and architecture. At the Bauhaus they were convinced that academic students were brought up in the false belief that they were geniuses. When they had completed their studies than they stood around incompetently in the world and unemployed on the street, because they were not educated comprehensively and in accordance with their times. At the Bauhaus, this would be different.

Gothic overtones: "Empty," designed in 1896 by William Morris for a book illustration.

--→ **The Darmstadt Artists' Colony, Mathildenhöhe.** This came into being in 1898/99 with the close cooperation of craftspeople and artists in various disciplines, among whom were Joseph Maria Olbrich and Peter Behrens.

--→ **The Deutscher Werkbund (German Work Federation), Founded in 1907.** Its aim was the "ennoblement of craftwork in the collaboration of art, industry, and crafts by means of education, propaganda and a common attitude to relevant questions." It called for "good form" and "quality work."

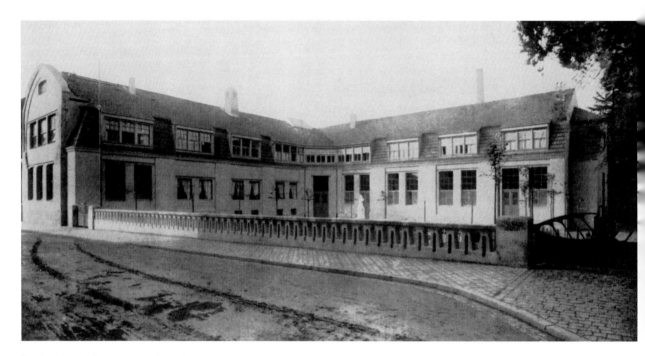

The Grand Ducal Saxon Arts and Crafts School in Weimar built in
1905–06 to the plans of Henry van de Velde. In 1919 the Bauhaus
workshops moved in here.

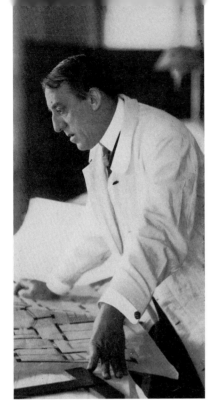

In 1906 Henry van de Velde founded the Grand Ducal Saxon Arts and Crafts School in Weimar, of which he was director up to 1915.

"A ceremony of our own"

The First World War assaulted mankind like a savage monster. Those who did not perish in the war suffered severe physical and psychic damage. In this time of chaos and upheaval, the demand grew for a new and better future. Open minds brought hope and a desire for utopia to a world of uncertainty. One of these visionaries was Walter Gropius.

In Search of a Director

The architect and artist Henry van de Velde was searching, not of his own free will, for a new director for the Grand Ducal Saxon Arts and Crafts School (Großherzoglich Sächsische Kunstgewerbeschule) which he himself had founded. Because of the war, it was difficult for foreigners to work in Germany and so the Belgian van de Velde was soon given notice to resign his post and find a successor. In 1915 he suggested the renowned Art Deco artists August Endell and Hermann Obrist, as well as the young architect Walter Gropius. Van de Velde, who was fifty-two, and Gropius, who was twenty years younger, had clearly different attitudes to art, architecture, and education, but also

> "... if we simply demand what appears impossible, I am convinced that we will succeed."
>
> **Walter Gropius, 1919**

points of contact. Van de Velde's request to put his name forward as a successor reached Lieutenant Gropius on the battlefield. He thought that as a *homo novus* he hardly stood a chance, but replied to Weimar accepting the nomination. But for the time being, the further development of this promising story was prevented by the war.

Gropius' Career

Who was this man, to whom van de Velde was making an offer that was to have such huge and unsuspected consequences?

The young upper-class Berliner had put his architectural studies on hold shortly before they were to have been completed. Instead, in 1908 he applied for a job in the innovative office of the architect Peter Behrens and was accepted. Within a short time Gropius had become a welcome guest in the Behrens' household and was even allowed to instruct Behrens' daughter Petra in tennis. That Gropius could hardly draw did not trouble his employer for a moment. But it did disturb the young, sensi-

tive novice. He wrote despairingly to his mother: "My absolute inability to transfer even the simplest concept to paper spoils many beautiful things for me and often makes me consider my future profession with anxiety. I am not capable to drawing a straight line ... for I immediately get cramp in my hand, break the points off the pencil, and after five minutes I need a rest ... Even in my darkest hours I did not fear that things would be so bleak. What is to become of me?" But the experienced Behrens recognized Gropius' abilities and versatility. He even took him with him on a study trip to England, where they studied factories and industrial plants. In Behrens' Berlin office Gropius not only assisted his employer in the latter's wide-ranging creative activity for AEG, which included designing the firm's logo, its buildings and their furnishing. He also made the acquaintance of another employee of the office, a man who also later became famous—Ludwig Mies van der Rohe.

By the spring of 1910 Gropius had already opened his own architectural office in Berlin, and shortly after-

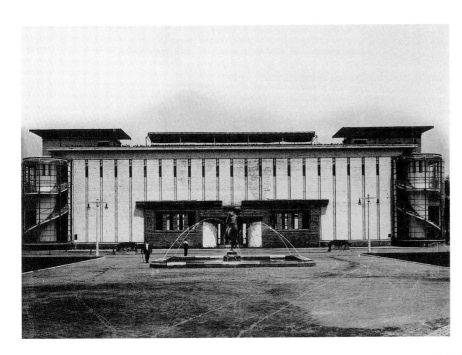

The office building for the pattern factory designed by Walter Gropius and his partner Adolf Meyer, with side stair-wells entirely of glass, at the Deutscher Werkbund exhibition in Cologne, 1914.

wards, together with his colleague Adolf Meyer, he designed a new factory building for the Fagus shoe-last factory at Alfeld, near Hanover. Here, turning away from the reiteration of historical styles, Gropius created something truly new, for the glass exterior walls of the factory were largely freed from their load-bearing and supporting function. A revolutionary glass façade of this kind was later to become a significant characteristic of the Bauhaus building in Dessau. Also in 1910, Gropius became a member of the Deutscher Werkbund (German Work Federation, an association of artists, designers, architects, and industrialists) and, as a committed young comrade-in-arms, he worked on its yearbooks. When, at the Werkbund exhibition in Cologne in 1914, a scandal broke out—the so-called "Werkbund dispute"—Gropius took sides with the established figure van de Velde. The cause of the dispute was a controversy between van de Velde and the architect Hermann Muthesius that nearly caused the breakup of the Werkbund. While Muthesius spoke out in favor of standardization in architecture and the industrial production of furniture

and other items, van de Velde defended free artistic individuality. In the context of this exhibition, Gropius clearly took up a position in agreement with van de Velde. Gropius was also represented as an architect at this exhibition, in fact with several buildings, all of which he designed especially for the exhibition: a pattern factory and factory office, the so-called Deutz Pavilion, which was designed to be the exhibition hall. This exhibition showed that the architect Gropius was also a versatile designer; not only interiors by him were on display, but also car bodies and a sleeping car.

"Artists, let us knock down the walls"

After more than four years of traumatic experiences at the Front, Gropius returned at a time of disruption and with an uncertain future. Immediately after being discharged from the army, he came back to a Berlin shaken by depression and revolution in order to "take part in the upheavals. There is an atmosphere of high tension here, and at this time we artists too must strike while the iron is hot." In December 1918, therefore, Gropius

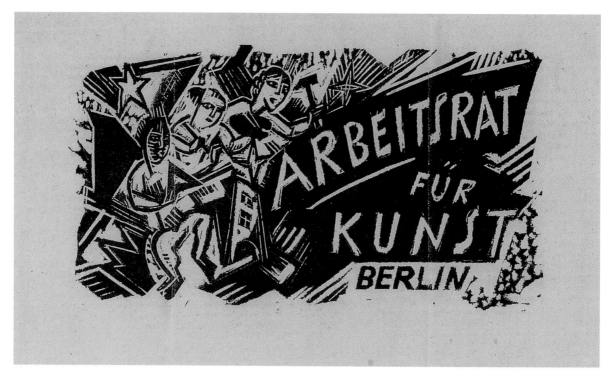

joined the newly founded Work Council for Art (Arbeit-
srat für Kunst), a group of architects and artists of a so-
cial-revolutionary disposition under the chairmanship of
the architect Bruno Taut. Here bold ideas were being
developed and radical programs forged, such as the
"Future Architecture Program," on which Gropius
worked together with Taut. Gropius was establishing
contacts with important personalities and making high-
profile public appearances, and within a few weeks he
had himself taken over the chairmanship of the Work
Council. In this atmosphere of turmoil and inspiration,
an idea was growing in the mind of Gropius that he had
had for some time. He wrote to a friend: "I am in the
process of setting up something that has been haunting
me for a long time—a builders' guild! With a few artists
who are kindred spirits. No external politics, only cross-
fertilization at regular meetings. An attempt at a cere-
mony of our own." But it was still totally unclear to him
where and in what form he would realize this ambition.
In April 1919 he organized the *Exhibition for Unknown
Architects* for the Work Council, which had already an-
nounced at its foundation the aim of "bringing the arts
together under the aegis of architecture." To accom-
pany this exhibition, a pamphlet was published in
which architecture was invoked as a *Gesamtkunst-
werk* (total work of art) on which artists of all the

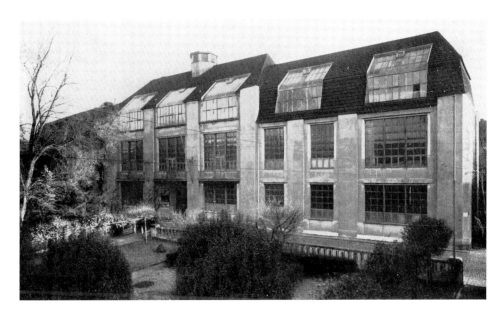

Grand Ducal Saxon Fine Arts College in Weimar by Henry van de Velde. From 1919 the workshops were located here, as were the Bauhaus classrooms and administrative offices.

disciplines would work together: "There is one comfort for us: the idea of a glowing, bold concept of building, rushing forward to bring forth the happier time that must lie ahead. Artists, let us at last knock down the walls that our distorting book-learning set up between the arts, so that we may all once again become builders!" Almost at the same time, Gropius inscribed this vision in the manifesto for his new institution—the Bauhaus.

"I am boisterously on my way"

Gropius had not forgotten van de Velde's proposal of 1915, and a new school with him as director, where he could realize his ideas and ideals, tempted him even more than it had earlier. The art college directed by van de Velde had admittedly closed long before. Instead, in early 1919 he was offered the directorship of the Grand Ducal Saxon Fine Arts College (Großherzoglich Sächsischen Hochschule für bildende Kunst) by the office of the lord marshal in Weimar. But Gropius did not just want to take up a directorship; rather, he had specific ideas about what his new school should look like. He made extensive demands, which included the amalgamation of the art college with the crafts school that had been closed. The postwar period was open to novelty and so his ideas were in fact approved. At the beginning of April Gropius received a contract as director and on 12 April 1919 the lord marshal's office also approved the renaming of the now united institutions as the State Bauhaus Weimar (Staatlichen Bauhauses Weimar). Gropius wrote to one of his first hosts in Weimar: "I am boisterously on my way to Weimar with the firm intention of making a whole entity out of my business ... My idea of Weimar is not a little one."

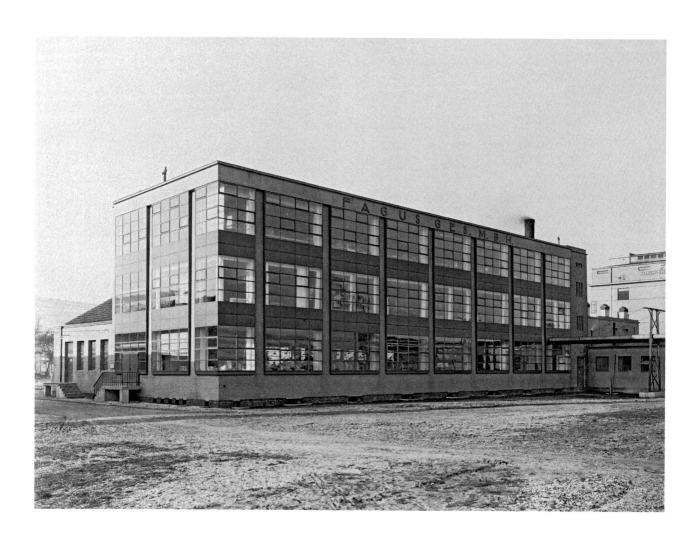

In 1911 Gropius was commissioned to design a factory building for the Fagus works, a shoe-last factory in Alfeld an der Leine near Hanover. With his partner Adolf Meyer he created a building that is now often described as the "original Modernist building."

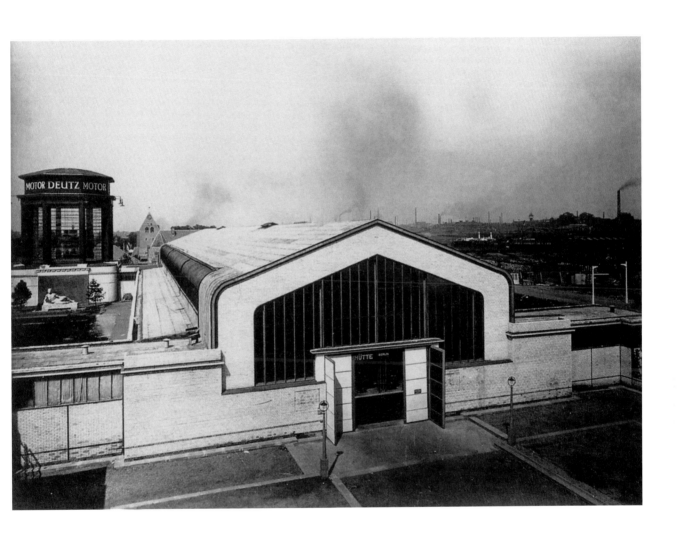

For the Deutscher Werkbund exhibition of 1914 in Cologne, Walter Gropius, with his partner Adolf Meyer, designed this machine hall and the so-called Deutz Pavilion, where gas engines were exhibited. Later, in the Bauhaus' Weimar period, Meyer worked in Gropius' architecture department. These buildings, which met with great recognition, were erected solely for the period of the exhibition and were then demolished.

Fame

"We know that trains and bicycles, Rembrandt and Hölderlin were not accepted at first. So we are not surprised if today—out of habit —contemporary design is slow to assimilate."

Josef Albers, 1925

"only one thing is forbidden: being an idiot"

There was praise and criticism in plenty for the Bauhaus in its day from critics, politicians, artists, and the Bauhaus directors and masters. But what did the students think of the Bauhaus? Here is a selection of statements noted by students during their exciting time at the Bauhaus:

--> **Gunta Stölzl**, preliminary course, Weimar 1919: "We do not want to become artists, but human beings, and intensify our looking, experiencing and sensing, and, simply because we can do no other, creating, or because it is on the path of creation that we are able to penetrate most deeply into life."

--> **Max Bill**, metal and stage workshops, free painting class, Dessau 1928:
"my impression of the bauhaus was not the one i had expected ... but gradually i did find what had actually drawn me here: clarity."

Bauhaus member Otti Berger, *c.* 1927, photographed by Lucia Moholy.

--> **Otti Berger**, weaving workshop, Dessau 1928:
"to become an artist, one must be an artist, and to become an artist when one is already an artist, that is why we come to the bauhaus; and to make a human being again out of this 'artist': that is the task of the bauhaus."

--> **Vera Meyer-Waldeck**, carpentry workshop, Dessau 1928:

"i was psychologically so calcified by education, school, and the academic atmosphere that i needed a very live organism to free me from this stiffness. this is why i came to the bauhaus. here i found people who were alive and well with much activity and vitality ... for me the value is not in what is taught, but in how it is taught. that one first trains and educates people who think and act for themselves before one conveys the necessary knowledge to them."

Negative image of
the Bauhaus member
Vera Meyer-Waldeck,
photographed in 1930
by Gertrud Arndt.

-→ **Albert Mentzel**, stage workshop, Dessau 1930:
"only a very few come here to carve out a career with
the bauhaus style. most people come with the genuine-
ly serious intention of entering a community which dif-
fers fundamentally from the contradictory world around
them, where they can develop new points of view for the
systematic creation of a new society."

-→ **Hans Keßler**, preliminary course, Dessau 1931:
"... one learns to play again like a child, one learns to
extract qualities out of a material that one did not yet
know about—just as the inventor does ... and to repre-
sent this materiality, everything is allowed: by all
means, use excrement! only one thing is forbidden:
being an idiot."

Bauhaus People: A Colorful Crowd

In 1929 the house journal of the Bauhaus gave an
interesting insight into the composition of the
Bauhaus membership: "140 are of german origin ...
30 are foreigners, namely: 8 swiss, 4 poles,
3 czechs, 3 russians, 2 americans, 2 latvians, 2 hun-
garian women, 1 german-austrian, 1 dutchwoman,
1 turk, 1 persian woman, 1 palestinian, 1 stateless
person, 119 are male, 51 are female ... 47 are bet-
ween 17 and 20, 90 are 21 to 25, 22 are 25 to 30,
11 are over 30 years old."

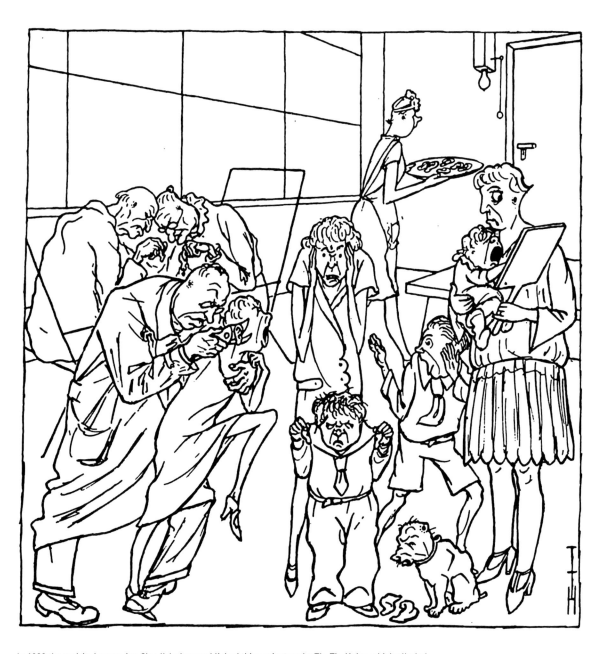

In 1928 the satirical magazine *Simplicissimus* published this caricature by Th. Th. Heine which alluded to Walter Gropius and the Bauhaus. Across it, like some terrible insult, was written the word "Sach-lichkeit!" (objectivity). The accompanying text reads: "In the relentless battle against ornamentation, a Dessau architect has cut off his own ears and those of his whole family."

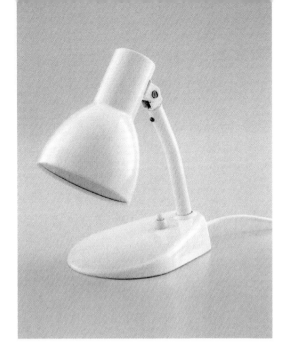

In 1928 Marianne Brandt and Hin Bredendieck designed this nightstand lamp for the firm of Kandem. It became a money-spinner and brought in a great deal of income for the Bauhaus from license agreements.

Battles and Bestsellers

Today, merely the word "Bauhaus" has for many people a magical aura. But between 1919 and 1933 the Bauhaus was subject to great hostility from many quarters. Its members were undeterred, however, sensing that traditional concepts of life and art were no longer future-proof and that only new, untrodden paths would lead to a better future.

Disputes in the "bastion of classicism"

Battle was declared on the Bauhaus when it had been open for only a few months. It was criticized and reviled—above all by conservative Weimar craftsmen and reactionary artists and citizens. Such an influx of the new can sometimes appear threatening. One art magazine railed: "The inhabitants of this small city are uneasily sensing that they are being coerced to reeducate themselves." Sometimes it was the Expressionist language of forms at the Bauhaus that was demonized, at other times Walter Gropius' central statement that the basis of all artistic work was a training in the crafts. Added to this was vilification by German nationalistic groups, who saw in the

> "I am fighting against a world of Philistines, but I have a phalanx standing behind me."
>
> **Walter Gropius, 1920**

In 1925 Bauhaus Volume 7 presented this lamp made out of glass and named K.J. Jucker and W. Wagenfeld as the designers. Wagenfeld also created a metal version. In the 1980s he reworked this Bauhaus icon once again.

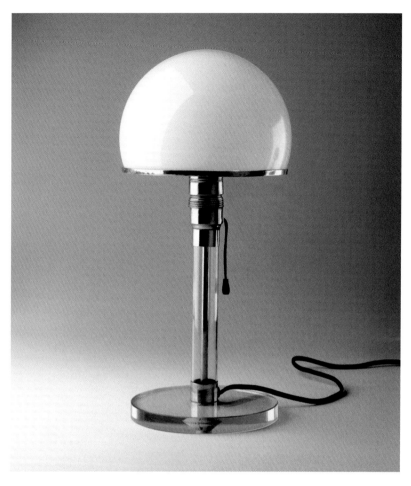

Bauhaus sometimes a communist, sometimes a Jewish institution, financed by public money. This, of course, was meat and drink to the press, and not only in Weimar. And so one day Gropius' mother in Berlin read about the unrest concerning the Bauhaus. Gropius wrote to her: "Little mother of mine, you should be pleased that I am not lurking in a corner, but standing in the front row and battling for truth and for my beliefs. After all, I am no moral coward ..." Gropius' many struggle with the critics became the "great battle of the Bauhaus." the hostilities in Weimar were the expressions of a general attitude of mind in which the old defended itself against the new. In a letter of December 1919 he wrote: "It is the beginning of the European intellectual revolution that is on its way. The conflict between the old world view, based on classical education, and one that is completely new ... It is not by chance that it is here in Weimar, the

bastion of classicism, that this conflict is breaking out for the first time, and most fiercely."

Prominent Advocates

As soon as the first critics had had their say, prominent supporters of the Bauhaus responded. The Deutscher Werkbund underlined the importance of the new institution, with architects such as Bruno Paul, Richard Riemerschmid, and Peter Behrens signing statements in support of the Bauhaus. Even the former curator of the Metropolitan Museum in New York, Wilhelm Valentiner, who was now director of the Detroit Museum, took up the cause of the Bauhaus and its program. Finally, the hostility was countered by statements, peti-

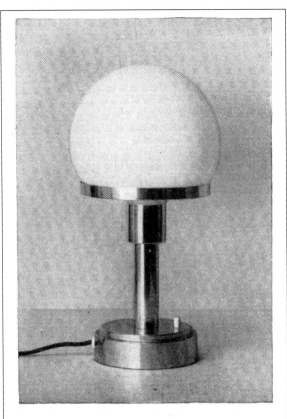

PILZ-LAMPE
03080 Druckschalter

The Bauhaus desk lamp was initially sneered at by manufacturers, but by 1939 it was so popular that it was "honored" by unauthorized copiers.

tions, and articles in the press in support of the Bauhaus. In 1924 the publicity-conscious Gropius made a book, which László Moholy-Nagy designed for him, out of all these positive statements. In the same year, the Circle of Friends of the Bauhaus (Kreis der Freunde des Bauhauses) was founded, to promote a better image for the Bauhaus, above all among the educated middle class. The board of the Circle of Friends included celebrities such as Marc Chagall, Gerhart Hauptmann, Oskar Kokoschka, and Arnold Schönberg.

Pilgrims, Plebs, and Proletarians

In Dessau, the newly erected Bauhaus building at once became a major center of attraction for curious visitors from all over the world, who daily arrived in their droves to form their own impressions. Sometimes there were as many as 200 visitors a day. From 1927 to 1930 the Bauhaus received a total of more than 20,000 visitors. Among them were industrialists, bankers, craftsmen, and artists, such as Tadeusz Papier from Poland. He observed: "If proof were still needed of the epoch-making achievements of the new art, this is where it can be found." The design of the building was repeatedly cited as the first brilliant victory over the 19th-century assortment of historical styles. The Russian writer Ilya Ehrenburg came and saw in it a "triumph of clarity." After his visit to Dessau, the American Alfred H. Barr, Jr., felt strengthened in his resolve to set up his Museum of

Modern Art in New York to accommodate not only fine art, but also architecture, film, and design. Often even ordinary citizens visited the Bauhaus. For some, admittedly, this concentration of avant-gardism was too much—during a guided tour, the Bauhaus member Marianne Brandt was threatened with sticks when she told a group of book printers that the Bauhaus had just introduced the exclusive use of lower-case letters.

Because so many saw the building as the model for a new architecture, it quickly became the bogeyman image for culturally conservative and nationalistically minded agitators. One of their main points of criticism was the flat roof, which was seen sometimes as "un-German," sometimes as "impractical." Here Paul Schulze-Naumburg, who called himself a "researcher into race," played a particularly unfortunate role. In 1926 the architect of the Cäcilienhof in Potsdam, the last of the German *Schloss* buildings, saw the roots of this new architecture in "East Asian, Indian, or even Negro art." In July 1932 he came as a National Socialist "authority" to the Bauhaus building in Dessau, to be taken on a guided tour by the new director, Ludwig Mies van der Rohe. The National Socialists' death sentence on the Bauhaus, however, was already signed and sealed. A few days later the Nazi leader of the city council wrote joyfully that now "one of the most striking sites of Jewish-Marxist 'art' is willingly disappearing from German soil."

Bauhaus Against Bauhaus Style

Gropius' dream was that the Bauhaus should be financially independent of public funding. For this reason, as many as possible of the workshops' products were to be

In 1931, after his period as director, Hannes Meyer (fourth from left) organized a Bauhaus exhibition in Moscow on his own initiative. Only work from his "Red Bauhaus" period were exhibited.

of good marketable quality. From 1923, articles were produced in series and exhibited at trade fairs. In 1923 Gropius founded a "Bauhaus Inc.," which was to market its products. In cooperation with the firms of Osram and Kandem, the metal workshop produced lamps that became bestsellers. This success was repeated with the Bauhaus wallpaper developed in the wall-painting workshop. And what did a magazine recommend to those who felt a little uneasy about bringing these products into their own homes? It assured them: "Slowly one will get used to these objects, which may at first seem unfamiliar, in fact suddenly the light will dawn: how obviously clear and wonderfully beautiful all this is."

But with fame and success, suddenly all the world was talking about the "Bauhaus style." Full of dismay, Ernst Kállai, the editor of the magazine *bauhaus*, explained what this concept implied: "Apartments with a great deal of glass and the glow of metal: Bauhaus style ... seating with tubular steel frames: Bauhaus style ... everything written in small letters: bauhaus style. EVERYTHING WRITTEN IN CAPITALS: BAUHAUS STYLE. Bauhaus style: a word for everything. Wertheim creates a new department ... a salon of crafts for objectively embellished, pretentious kitsch. The name of the Bauhaus must serve as a particular attraction." Of course the Bauhaus members protested against this label, for the concept of a style was to have been overcome with the foundation of the Bauhaus. But this concept, which described something that actually did not exist, became stubbornly burned into the general vocabulary and simply never went away—up to the present day.

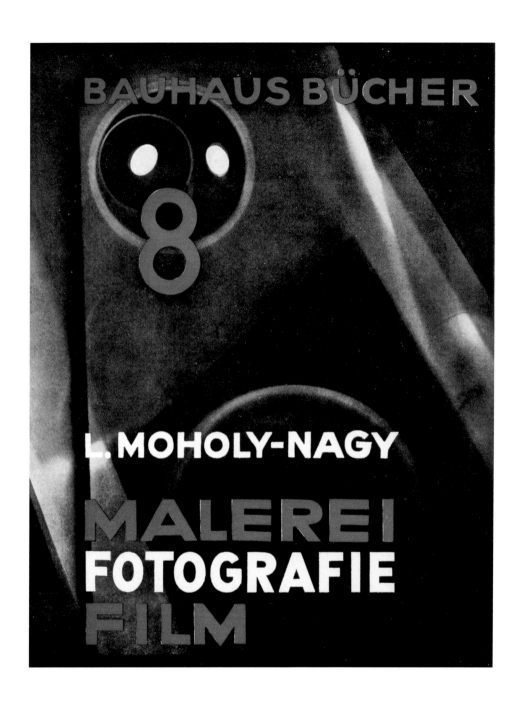

Jacket of Bauhaus Volume 8, designed by László Moholy-Nagy. In 1925 the first eight volumes of the "Bauhaus books" were published, which, as the Bauhaus announced, "are concerned with the problems of life today." Originally fifty different titles by Bauhaus masters and contemporaries who were close to the Bauhaus were planned for the series. In the event, up to 1930 only fourteen of these promotionally effective texts were published, most of them with typography designed by Moholy-Nagy.

Bauhaus wallpapers from the first collection of 1930. The topic of wallpaper was discussed at length and critically at the Bauhaus. It was the wallpaper manufacturer Emil Rasch who persuaded Hannes Meyer that wallpapers were appropriate and inexpensive wall coverings for the people's apartments promoted by Meyer. The series, first produced in 1930, of unornamented, structured "bauhaus wallpapers," had emerged from a competition among students. They remain successful even today.

School

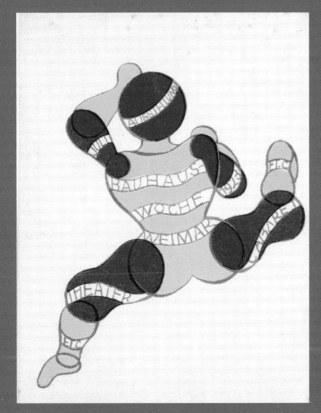

"The responsibility of the Bauhaus consists in forming human beings who recognize the world in which they live and who, out of the connections between their realizations and their acquired skills, are able to devise and design distinctive forms that symbolize this world."

Walter Gropius, 1923

Friends, Guests, Companions

The Bauhaus was not a self-contained island. It attracted international personalities from the intellectual and artistic life of the period. Some came only briefly to look at the Bauhaus exhibitions and the school of which so much was being reported in the art world. Others were invited to give evening lectures and thus extended the cultural and social life of the Bauhaus.

Mies van der Rohe (right) with the French painter and co-founder of Purism, Amédée Ozenfant, who came to view the Bauhaus in 1931.

-→ In October 1927 the "dada leader" Johannes Baader gave a lecture.

-→ In 1927 the Hungarian composer Béla Bartók gave a concert for Bauhaus members in its assembly hall, and played a sonata of his own which had never been heard before.

-→ The MERZ artist Kurt Schwitters organized several recitation evenings at the Bauhaus in Weimar and Dessau.

-→ In April 1920 the poet Else Lasker-Schüler read some of her poems in the context of the Bauhaus evenings.

-→ In November 1928 the Russian sculptor Naum Gabo gave a talk called "An Introduction to My Work."

-→ In 1928 the Russian artist El Lissitzky lectured on the subject of "Architecture and Workmanship".

-→ In April 1929 the American composer Henry Cowell played his own works for piano in the Bauhaus assembly hall.

Gret Palucca, Nina and Wassily Kandinsky and an unknown person on the terrace of one of the master houses, Dessau 1928.

What Leaps!

The dancer Gret Palucca fascinated both masters and students with her dance evenings, which she organized several times at the Bauhaus in both Weimar and Dessau. Wassily Kandinsky was inspired to create structural studies by photographs of Palucca dancing. László Moholy-Nagy commented: "Her body, she herself, is a creative medium of the purest expression of a new dance culture."

The Bauhaus in India

The first Bauhaus exhibition outside Europe took place in Calcutta in 1922 at the invitation of the Indian painter Abanindranath Tagore. Altogether, 250 works, by Feininger, Kandinsky, Itten, Muche, and Klee among others, as well as work by students on Itten's preliminary course, were shown. The works were for sale at prices between £5 and £15. But only one painting was bought—for £3. It was by the student Sofie Korner.

The link with India had existed for some time. In October 1921 the great master of classical Indian music, Murshid Inayat Khan, had given a concert for the Bauhaus members in the "Oberlichtsaal" in the Weimar Bauhaus building.

What Eyes!

Marlene Dietrich was not yet a world star when she studied violin in Weimar in the early 1920s and lived in a small pension, where the Bauhaus master Lothar Schreyer and his wife also had a room. One day Marlene asked the Schreyers if they could put her in touch with Alma Mahler, who was at that time still married to Walter Gropius. Alma Mahler came, met Marlene and said in fascination to everyone present: "What eyes the child has! What eyes!"

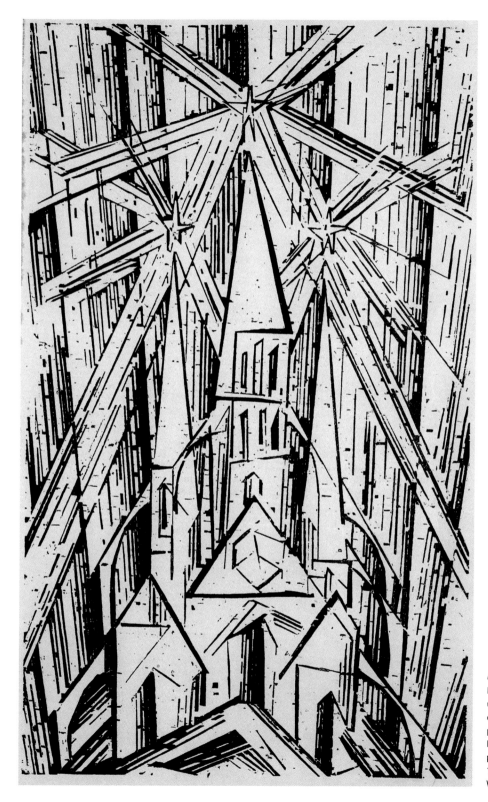

Cathedral, a woodcut by Lyonel Feininger used on the title page of the manifesto and program of the State Bauhaus in Weimar, published in April 1919 and written by Walter Gropius.

Walter Gropius
in 1920.

The Laboratory of Modernism

The Bauhaus was in existence for only fourteen years and was attended by almost 1,300 students. It was the meeting place for ideas and characterized by great artistic personalities. Since it was continually exposed to political attacks, it moved from Weimar to Dessau and later to Berlin. Its directors, Walter Gropius, Hannes Meyer, and Ludwig Mies van der Rohe gave very different impulses to the school.

A Manifesto for a New Age

The chaotic period after the First World War was characterized by great uncertainty, with many having no clear idea of the future. But one thing was clear: life would have to change if something fundamentally different were to emerge. In April 1919 Gropius wrote a manifesto for his new school, the Bauhaus. He was a man a clear vision of art and society—and of the education of young people. Gropius knew that a new world could only be built up with people who had experienced

> "The Bauhaus will never become contented with itself, or it will not be the Bauhaus any more, and anyone who is there must take part, even if he does not want to."
>
> Paul Klee, 1929

The Bauhaus signet by Peter Röhl (right) was used for official purposes from 1919. The design was the result of a competition among the students. In 1922 Oskar Schlemmer designed a new signet (left), which was used from then on.

an appropriate form of education. His ideas immediately attracted many young people searching for a way to bring about change and participate in creative design. Gropius clearly identified aims and methods for a modern education, and sketched out a new species of people working in the arts and crafts. According to him, art could not be taught, and "art as a profession" did not exist. Rather, he demanded that education in the crafts should once again become the basis of all artistic work, since for him the artist was a heightened form of the craftsman. He planned to put into practice what other movements for reform, rejecting the usual academic education, had realized only in part and unsatisfactorily. The ideal of the reformer Gropius was that painters, sculptors, architects and craftsmen from various disciplines should work together in a "new total architecture." Gropius's concept also stemmed from his preoccupation with medieval builders' huts, in which craftsmen and artists worked together to build cathedrals. Obviously he was thinking of these builders' huts when he chose the name "Bauhaus." At the end of his

revolutionary manifesto Gropius wrote this appeal: "Let us desire, conceive and create the new building of the future together. It will combine architecture, sculpture, and painting in a single form, and will one day rise towards the heavens from the hands of a million workers as the crystalline symbol of a new and coming faith." This aim was a utopia, a longing for which was now to be of help in abandoning all the incrustations of the past. Thus the title page of this manifesto is adorned by a star-crowned cathedral designed by Lyonel Feininger, which seemes to grow endlessly into the heavens.

The Workshop Principle

For Gropius, training in a workshop was the decisive principle, the core of the new institution. He looked for masters for his workshops who were artists and could accompany the work of the students, and at the same time transmit skills in craftsmanship. However, at first it proved difficult to find individuals who combined both abilities. From then on, therefore, two "masters" shared the direction of the individual workshops: a

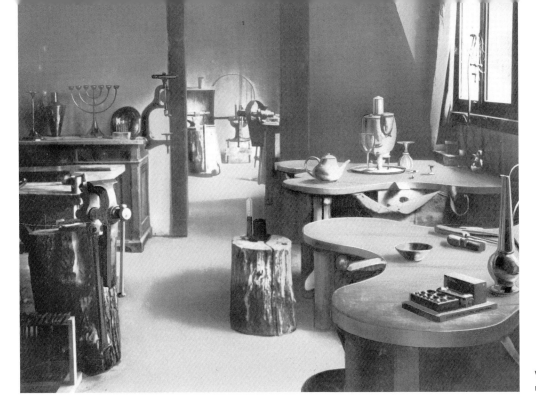

View of the Weimar
metal workshop, *c.* 1922.

"work master" (Werkmeister) and a "form master" (Form-meister). The work master was a craftsman and taught basic practical skills in the "study of handicrafts." The form master was an artist who assisted the students in formal artistic design. In the first year, Johannes Itten and Georg Muche, as form masters, led almost all the workshops—there were not yet enough suitable artists for the task. From 1920 every workshop had its own form master. However, there was improvisation during these years. This was in fact intentional. Gropius did not want a school where every minute detail was planned and organized, but an open, experimental structure that would allow his form of education enough room for new initiatives.

The Bauhaus started with four workshops in which the students could train: a smith's for gold, silver and copper, later renamed the "metal workshop," a book-binding workshop, a printing workshop, and a weaving workshop. In 1920 several more workshops were added. The students could now, in addition, choose between workshops for ceramic, glass painting, wall painting,

and sculpture in wood and stone. In 1921 a carpentry workshop and a stage workshop were set up, which any interested student could attend, even if studying prima-rily in the other workshops. All the workshops were housed in the Bauhaus building in the center of Weimar, except for the ceramics workshop, which moved into a "Goethe castle" in Dornburg an der Saale. Considering how much importance was given to architecture by Gropius in his Bauhaus manifesto, it is surprising that there was no architecture class. This was not in fact achieved at Weimar, apart from sporadic courses in architecture and occasional assistance in Gropius's private architectural office. Only in Dessau, in 1927, was an architectural department finally set up.

The Secret Director

In the early days Gropius realized that many students were not yet in a position to tackle something radically new in their training at the Bauhaus. Many brought along preconceived opinions and ideas. Gropius reacted to this by introducing an elementary class, the so-called

preliminary course, which was later adopted in a similar way worldwide in education. This preliminary course, originally called *Vorlehre* and later *Vorkurs*, became mandatory for all beginners from the spring of 1920. Only after this six-month basic course would a decision be made for the student's admission to a suitable workshop. The preliminary course was intended to awaken the creative potential of the young people, and free them from all traditional artistic styles of thought. It was supposed to counteract too early a specialization and provide the basis for a holistic education. For this reason, the students were meant to train their perceptions and senses, and thus discover their own creative potential. The structure of this teaching in the early years is inextricably associated with the Swiss artist Johannes Itten. Gropius met Itten in Vienna, where the latter had developed and tested the preliminary course method at his own art school. Itten was a charismatic presence, a man with a shaven head, rimless round glasses, very individual clothing which he designed himself, and a decisive manner. Artistically and intellectually he was character-

ized by his studies in painting at the Stuttgart Academy under Adolf Hölzel and by his own studies in Eastern and Western philosophy as well as occult and mystical teachings. He wanted to train not only the minds of the students, but also their bodies and souls. A day with Itten in the preliminary course therefore began with physical and breathing exercises, to loosen students up and promote concentration. For him everything that could be perceived was determined by opposites, as he conveyed in his teaching on contrast. The students thus continually tried, in practice with paint, charcoal, or other materials, to demonstrate opposites creatively in pictures or collages of paper or fabrics. Itten even sent

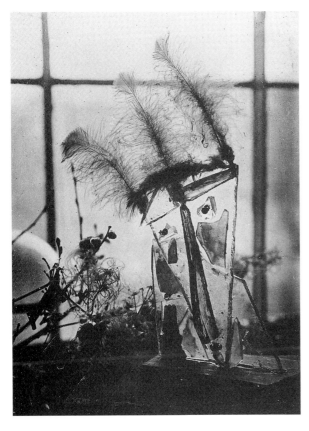

A sculptural material study by Margit Téry-Adler from the preliminary course run by Johannes Itten. Itten was concerned that an object should be created from the most varied materials, which would bring out the essential and conflicting qualities of the materials used.

the students to find materials for collages in trash cans, at garbage dumps or salvage yards. On their return to the Bauhaus, they constructed from the wires, glass, or stovepipes collages which were supposed to demonstrate opposing qualities such as sharp/blunt, rough/smooth, or large/small. In nature study with Itten, they would draw what they had seen as precisely as possible from memory. In the life class, Itten sometimes played music on the phonograph to make it easier for the students to transfer what they had seen to paper in a rhythmical manner. The study of paintings by Old Masters was also part of his program. He encouraged the students first of all to grasp these images purely from their feelings, and only then to analyze them intellectually. In this way he wanted to train them in the different approaches to the understanding of images, by both emotion and intellect. Itten left the Bauhaus in 1923 after lengthy, simmering conflicts with Gropius. Schlemmer summed up: "Itten was the secret director."

Itten's teaching was supplemented by the "harmonization study" taught by Gertrud Grunow. Grunow was already aged nearly fifty when she came to the Bauhaus, where she stayed until the move to Dessau. In individual sessions she tried to bring the physical and psychological qualities of the students into balance by means of sound, color, and movement. What was a class like with this "guardian of souls," as Grunow was jokingly called by students? Students were asked to imagine a prescribed color, while at the same time allowing a sound to exercise an intensive effect on them. They were then to develop movements intuitively from his inner impressions of the color and sound.

A Color Penetration of Yellow and Violet by the student Franz Singer, based on Paul Klee's teaching on color (*c.*1923).

Avant-garde Artists as Masters

Gropius had not only the ability to put into practice previously unrealized ideas and reforms at the Bauhaus. His farsightedness and his wide network of contacts also enabled him to bring an international band of avant-garde artist personalities, who no longer wanted to teach at the conservative academies, to the Bauhaus as masters. Even before the foundation of the Bauhaus, Gropius was convinced that the enterprise could succeed only with the help of outstanding personalities. He wrote in 1919: "We must not start with the mediocre, rather it is our duty to attract strong personalities, well known in the world, even if we do not yet inwardly understand them."

In the foundation year, 1919, he appointed several artists as Bauhaus masters. They included the painter Lyonel Feininger, who enjoyed success with his Ex-

pressionist works and, like Gropius, was a member of the Work Council for Art (Arbeitsrat für Kunst). Feininger soon took over the direction of the printing workshop. Before his appointment he had already become fascinated by the idea of the Bauhaus and asked a friend if the Bauhaus was looking for painters. He was told, "You are already on the list." Gerhard Marcks was a sculptor whom Gropius had known from their childhood days. He had made reliefs for Gropius's buildings at the Werkbund exhibition and also gathered experience in a ceramics factory. This made him the right man to set up a ceramics workshop. In October of the same year, Johannes Itten was appointed to the Bauhaus. He was to play a distinctive part in shaping the early years of the Bauhaus.

In 1920 the painter Georg Muche was added to the circle of masters. He led the preliminary course, al-

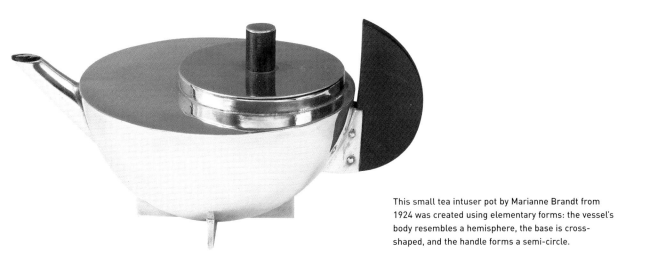

This small tea intuser pot by Marianne Brandt from 1924 was created using elementary forms: the vessel's body resembles a hemisphere, the base is cross-shaped, and the handle forms a semi-circle.

ternating with Itten. One year later, he was director and form master of the weaving workshop, one of the few male presences in this female-dominated workshop. In 1921 Lothar Schreyer and Paul Klee came to the Bauhaus. Schreyer, the Expressionist writer and man of the theater, was to set up a stage workshop at the Bauhaus. This was new and unique—no other school of art or architecture at that time had a drama class, and it became a place of experimentation, where the relationship between man and space, color, form, and sound were researched through exercises. Klee was already a famous artist and immediately recognized that he was in a circle of individualists with differing artistic directions, in which his art was not uncontroversial. Like Feininger, Klee had no teaching experience. To complement the preliminary course, he developed a class in what he called "Elementary Design" (Elementare Gestaltungslehre). His teaching consisted of lectures and practical exercises. In the same year, the painter Oskar Schlemmer entered the circle of masters and first took over the sculpture

workshop. Wassily Kandinsky too was already a famous man when he came to the Bauhaus as a master in 1922. His painting was abstract, and he had already written his groundbreaking text, *Concerning the Spiritual in Art*. Up to 1925 he was form master for the wall-painting workshop. As a complement to the preliminary course, Kandinsky offered the courses on "Analytical Drawing" (Analytisches Zeichnen) and "Abstract Study of Forms" (Abstrakte Formenlehre), which also included teaching on forms and colors. Both Kandinsky and Klee lastingly influenced the creation of many designs and products of the workshops in Weimar and Dessau. All these artistic personalities were very different, and their respective teaching methods were equally individual.

The "Beehive" Principle

Anyone could apply to study at the Bauhaus. But, as Gropius wrote in the Bauhaus prospectus, only applicants "whose educational background is considered adequate by the council of masters of the Bauhaus" would

In 1922 Gropius published this schedule showing the structure of teaching at the Bauhaus.

VORLEHRE

VORLEHRE

MATERIAL- UND WERKZEUGLEHRE

NATURSTUDIUM

LEHRE DER KONSTRUKTIONEN UND DER DARSTELLUNG

LEHRE VON DEN STOFFEN

1-2 JAHR — 3-JAHRE

TON STEIN HOLZ METALL

GLAS FARBE GEWEBE

BAU
BAUPLATZ
VERSUCHSPLATZ
ENTWURF
BAU U. INGENIEUR-WISSEN

RAUMLEHRE · FARBLEHRE
KOMPOSITIONSLEHRE

ELEMENTARE FORMLEHRE
MATERIESTUDIEN IN DER VORWERKSTATT

be accepted. Some students were only fourteen years of age and still quite wet behind the ears, while others already had completed training in a profession or a course of study at a university, and had come from the war. Each semester there were 120 to 200 students at the Bauhaus, who would complete their studies after six to eight semesters as apprentices and journeymen, after being examined by the local chamber of crafts.

Gropius wanted the students not simply to undergo training. Beyond this, he was concerned about their wide-ranging education as human beings and the development of their characters. He wanted Bauhaus members who would actively participate in both design and decisions, and who would take on responsibilities. During the Dessau period, looking back, Ise Gropius noted in her journal that "something came of the bauhaus only because gropius was not afraid to give responsibility to young people. sometimes it goes wrong, but when it succeeds, it is irreplaceable." Gropius therefore also made student representation possible, which exercised a significant influence on Bauhaus activities. The Bauhaus consisted of the director, the masters, and the students, a group which Gropius referred to as his "beehive." His aim was a Bauhaus community, democratic in nature, whose members fundamentally valued and respected each other—and also celebrated, laughed and played together. Gropius later wrote: "Young people came from Germany and abroad, not to design 'correct' lamps, but to take part in a community whose aim was to create new human beings in a new environment and at the same time to set free their creative spontaneity."

From Battleship to Bauhaus Villa

Gropius continued to run his private architectural office in Weimar. In 1921 he received a commission

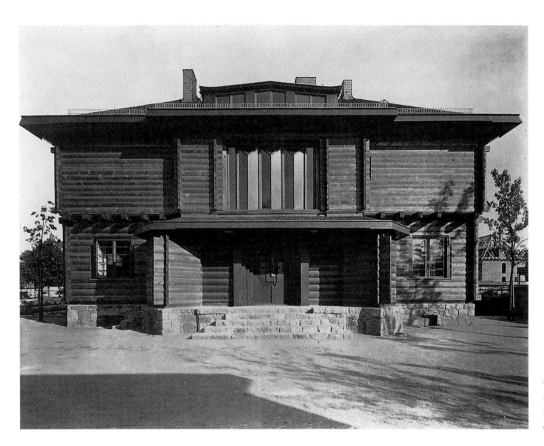

The house completed in 1921 for the Berlin property developer Adolf Sommerfeld.

from the building contractor Adolf Sommerfeld, who wanted a house of his own in Berlin. In the postwar period it was barely possible to find building materials, but Sommerfeld had obtained some quite special material—wood from a decommissioned German battleship. And so Gropius designed from this wood a villa whose style combined Expressionist and Japanese elements. It was in effect a symbol: something completely new being built from the material of the traumatic past. For the first time, too, he saw the possibility of involving students in the project taken on by his architectural office. The most talented students from the various Bauhaus workshops made plans, designs and models for the Haus Sommerfeld project. Gropius's demand in his manifesto was now for the first time becoming a reality, even if on a small scale: artists trained in the crafts were working

together on a building as a *Gesamtkunstwerk* (total work of art).

The Troublemaker

In 1922 the Bauhaus, suddenly disrupted, experienced an impetus which would in time have an impact on its program. Since 1921 the Dutch painter Theo van Doesburg had been staying in Weimar, in the constant hope of teaching at the Bauhaus. He was a member of the artists' group De Stijl, to which Piet Mondrian also belonged. Doesburg pursued with intense interest the development of the Bauhaus and was at first a great admirer, and then an increasingly fiery critic. This might have had something to do with the fact that Gropius found him too radical, too aggressive, in his demeanor, and did not appoint him to a post at the Bauhaus. Doesburg was obsessed with a clear, Constructivist

Theo van Doesburg was
not allowed to teach at the
Bauhaus. But in 1924
he was able to publish
his work *Principles of
Neoplastic Art* as Volume 6
of the Bauhaus books
with this cover, which
he designed himself.

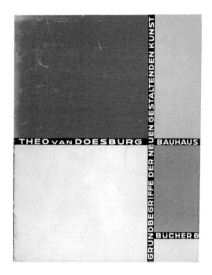

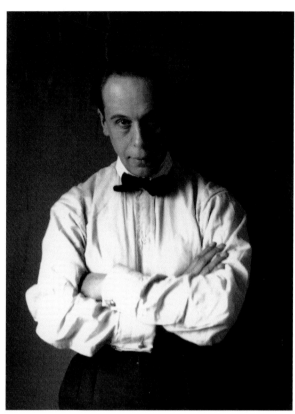

design system—a "style," as the name of his artists' group unequivocally announced. But a style was not what Gropius was concerned about at the Bauhaus. However, more and more students began to be interested in the agitator and his theories. And because Doesburg could not get into the Bauhaus, interested Bauhaus members went to his studio to enroll in his courses. It was like a madhouse there. Accompanied by drums and "Constructivist music," Doesburg proclaimed his theories at the top of his voice to the participants. He wanted to reduce art to clear, hard-and-fast forms such as rectangular linear constructs and primary colors combined with black, white, and gray. He spoke out against the individual and championed the use of machines to create art. A number of Bauhaus members were fascinated by his ideas, and many works produced by students during those years, such as Marcel Breuer's furniture, show the influence of Doesburg. At the Bauhaus, the Doesburg enthusiasts were observed with both dismay and approval. Feininger wrote in a letter to his wife Julia: "Why,

wherefore, this willing submission to Doesburg's tyranny and complete recalcitrance in the face of all measures or even requests coming from the Bauhaus?" On the other hand, Feininger observed: "Doesburg would be a good antithesis at the Bauhaus to the individuality, the romanticism, that haunts it."

"Art and Technology: a New Unity"

In 1923 the Bauhaus took a new direction. Now Gropius announced: "Art and technology: a new unity," a slogan which would characterize the Bauhaus from now on. This was also the beginning of the slow move away from an Expressionist language of forms. Doesburg's continual circling around the Bauhaus and his Constructivist sermons were not quite guiltless where this new orientation was concerned. But Gropius himself saw that the Bauhaus had to change. He recognized the increasing

Figurine by Lothar Schreyer,
made in 1923 in semi-sculptural form
as a body mask for his *Moon Play*.

importance of industry and the opportunity to open up new paths pointing to the future by means of cooperation between the Bauhaus and industry. He also hoped that such cooperation would improve the financial situation and make the Bauhaus independent of state support. The aim now was to create designs and prototypes for industrial serial production. This new direction could be sensed at the Bauhaus as early as 1922. In June Schlemmer wrote in his journal: "Renunciation of utopia. We can and should strive only toward the most real, the realization of ideas. Instead of cathedrals, the machine for living. Renunciation of medievalism, and of the medieval concept of craft ... Instead of ornamentation, into which an unobjective or aesthetic craftwork led by medieval concepts necessarily moves, functional objects that serve a purpose."

With the new direction, Itten, who unlike Gropius favored exclusive concentration on crafts and individual work, left the school. Schreyer, the director of the stage workshop, who pursued mystical aims with his Expressionistically colored art, also left the Bauhaus. From then on

Schlemmer took over the direction of the workshop. Gropius now brought a young artist to the Bauhaus who formed and definitively advanced the new direction even though, or perhaps because, he was a self-taught artist and teacher. This was the multi-talented Hungarian painter László Moholy-Nagy, then only twenty-eight. With Itten's departure, the preliminary course was revitalized. Josef Albers, himself still studying at the Bauhaus, took over the first semester, and Moholy-Nagy, as form master of the metal workshop, ran the second semester of the preliminary course, which now

A self-portrait created out of light: photogram and collage *c.* 1926 by László Moholy-Nagy, who sometimes called himself "Lichtner" (Light Maker).

lasted a year. Moholy-Nagy believed in the development of technology with the aim of a better world, with man at its center. He experimented in optics, in projection, mechanics, film, and photography. In his preliminary course he trained the students' senses and sense of space. He presented himself as a "researcher into being," who studied the basic qualities of materials and elements of creative work.

The Great Bauhaus Exhibition

In 1923 the Bauhaus became a showhouse with a large exhibition in Weimar. For months everything turned around this event, and no new students were accepted at this time—everyone was too busy. The exhibition opened in August. Work from all the workshops was proudly presented. Visitors who fell for a carpet, a child's chair, or an ashtray could buy them on the spot; a coffee cup from the Bauhaus pottery started at 1.60 marks, and a matching coffee pot was 18 marks. The master painters also showed their paintings. In the school building, wall paintings and reliefs by the mas-

ters and students could also be marveled at. In addition, Gropius put on specially for this occasion an architecture exhibition of the future stars of the international architecture scene, with designs by Le Corbusier and Frank Lloyd Wright among others. The opening of this display of work was accompanied by a "Bauhaus Week." Works by the composers Paul Hindemith and Ferruccio Busoni were premiered, and the *Triadic Ballet*, which Schlemmer had already devised before his time at the Bauhaus, was performed. Also on the program were performances by the stage workshop, and many other artistic highlights.

For this wide-ranging exhibition the Bauhaus even built a "model house" in Weimar. It was designed by one of the youngest Bauhaus masters, the painter Georg Muche. Gropius himself had a design of his own, but the self-confident students voted democratically on the awarding of the commission and decided against Gropius' design and in favor of Muche's. Gropius accepted the decision and replied to them: "Your momentum—whether or not it is born of delu-

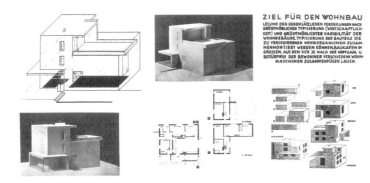

ZIEL FÜR DEN WOHNBAU

LÖSUNG DER GEGENSÄTZLICHEN FORDERUNGEN NACH GRÖSSTMÖGLICHER TYPISIERUNG (WIRTSCHAFTLICH-KEIT) UND GRÖSSTMÖGLICHER VARIBILITÄT DER WOHNGEBÄUDE. TYPISIERUNG DER BAUTEILE DIE ZU VERSCHIEDENEN WOHNORGANISMEN ZUSAM-MEHMONTIERT WERDEN KÖNNENBAUKASTEN IM GROSSEN, AUS DEM SICH JE NACH DER KOPFZAHL U. BEDÜRFNISS DER BEWOHNER VERSCHIEDENE WOHN-MASCHINEN ZUSAMMENFÜGEN LASSEN.

Gropius' designs for cube-shaped, standardized, variable "building components," assembled for various "machines for living." He called this principle "building blocks on a large scale."

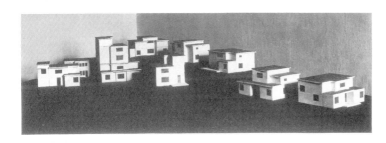

tural and livable expression of a new attitude toward life for modern mankind. One sees this both in the first modern kitchen with continuous work surfaces, and in the children's room, which had furniture and toys made in accordance with the latest educational principles. Some visitors were fascinated, most were shocked. One newspaper reported: "Tall floor lamps of iron and glass tubes, merciless, without any dim silk shade, are reminiscent of physical machinery, seating looks like weaving looms, furniture recalls printing presses, teapots are like the gauge glasses used to measure a water column."

sion—is the nerve of our exhibition. I am ready and will take part." This model house, the Haus am Horn, was erected on a site that Gropius had much earlier earmarked for a Bauhaus settlement, and was markedly different from any one-family house known up to that date. In the center of the one-story house with a cubic ground plan lay the high-ceilinged, square living room around which all the other rooms were arranged. The furnishings came almost without exception from the workshops. Functionality and economy were the premises of the design, in order to facilitate the life of the occupiers of tomorrow. It was to be the architec-

"Dancing around the golden calf of the Bauhaus"

During the whole Weimar period the Bauhaus was constantly exposed to attacks and smears from the right-wing political camp, conservative arts and crafts circles

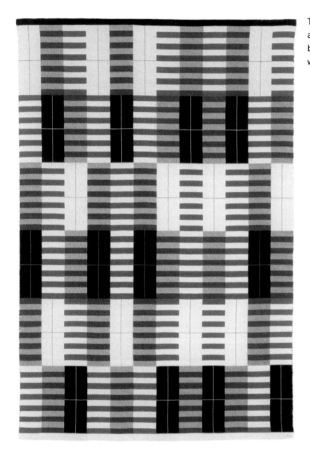

This is not an experimental design for a serial settlement but a wall hanging by Anni Albers, which she wove in the weaving workshop in 1926.

and from parts of the Weimar population. In April 1924 the situation came to a head and the rumor was spread that Gropius's contract as director would not be renewed. In this crisis it emerged that the community of masters could be relied upon. They stood behind Gropius and threatened to leave the Bauhaus at once if Gropius were to be given notice. This threat worked at first. But the figures in a current report by the audit office spoke for themselves, and the masters had no power to argue against them. The report recognized the artistic achievement of the Bauhaus, but criticized the book-keeping, and on account of its catastrophic financial state gave the school no hope for the future. This situation was of course more than convenient to a number of critics. Thus the Thuringian government announced that the contracts of the director and masters, valid up to April 1925, would probably not be renewed. Since no clear solution offered itself, Gropius made it his business to ascertain the facts. He made it known that he and the masters would terminate their contracts from April 1925, and left it open as to whether the Bauhaus would continue in a different place. Meanwhile, cities which were keen to welcome the Bauhaus were standing in line, Frankfurt am Main, Hagen, Mannheim, Darmstadt, and Dessau among them. Now began the "dance around the golden calf of the Bauhaus," as Schlemmer noted. A city in central Germany, Dessau, with its liberal mayor Fritz Hesse and his adviser, the art historian and local official for historical conservation Ludwig

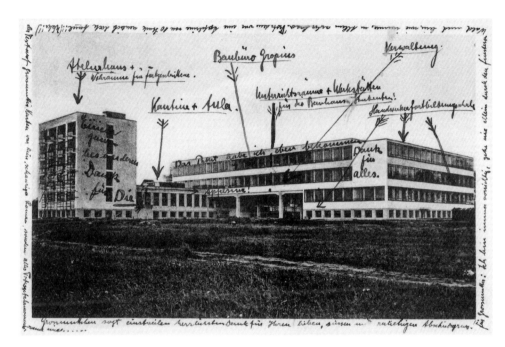

Postcard of the Bauhaus building from the northeast, described in 1927 by an unknown Bauhaus member to his family.

Grote, opened its arms to the Bauhaus. That Dessau was also an emergent seat of industry, where Hugo Junkers manufactured his aircraft, was very convenient given Gropius' aims. Feininger commented: "Gentlemen, we are all Weimared out; now we are going Dessauing."

The Floating "Jazz Building"

Since there were no suitable spaces in Dessau for the Bauhaus, Gropius was commissioned by the city to design a new school building. As early as mid 1925 the designs were produced by Gropius's architectural office, and building began in the fall. A year later, the ceremonial opening of the new school building was held. More than a thousand guests from all over the world came, were amazed, appalled, or simply speechless at what they saw there. The building they were gazing at in amazement looked like anything other than a school. Several individually designed, overlapping cubes formed the building, a principle that Gropius christened the "building blocks on a large scale." The roof was not pointed as usual, but flat. The most modern building materials were used, such as reinforced concrete and glass, in a frame construction. Standing in front of the workshop wing of the building complex, all one saw was a façade of steel and glass, which looked like a glass curtain (which is why it was called a "curtain-wall"). Here, interior and exterior entered into an unprecedented relationship. And was gravity being conquered here? From a distance, the white-plastered building complex

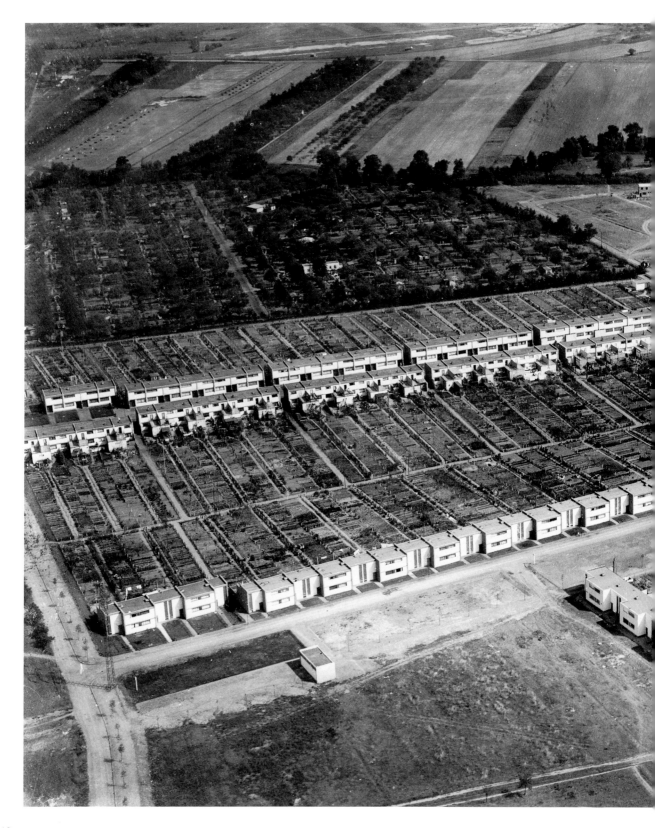

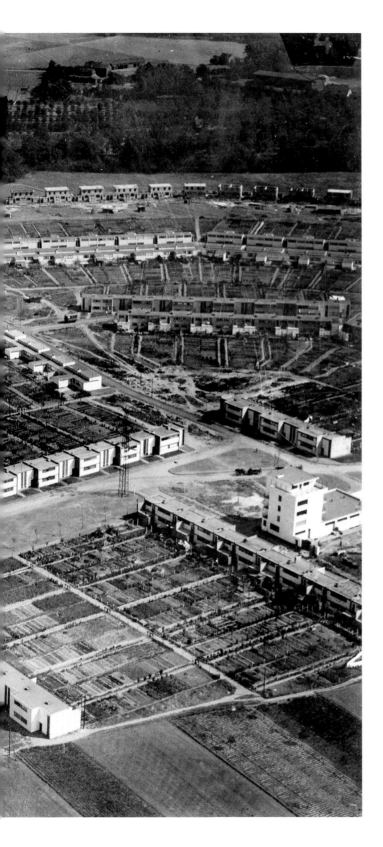

The Dessau-Törten settlement by Walter Gropius, aerial view of 1929. The 314 houses for the settlement were built in three sections. Each of these one-family houses had a kitchen garden, which would enable low-income families to be partly self-sufficient in fruit and vegetables. The purchase price of a house was at that time 10,000 Reichsmark, which made it affordable for workers.

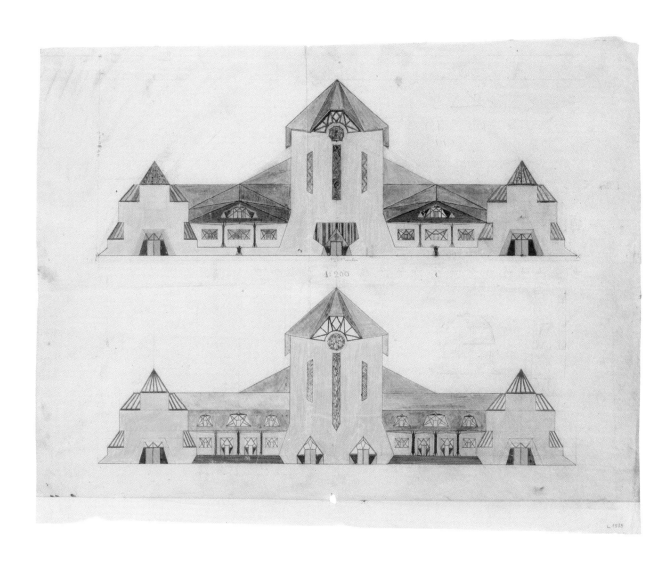

After the founding of the Bauhaus, Gropius planned to found a Bauhaus settlement in Weimar. Here there would be residential houses with fruit and vegetable gardens for the use of the Bauhaus members. In 1920 the student Walter Determann created a design that even included a children's preparatory school, a theater, a stadium, a gymnasium, and a swimming pool. The illustration shows the design for a crystalline main building for the complex. Despite many attempts, for financial reasons the settlement was never built.

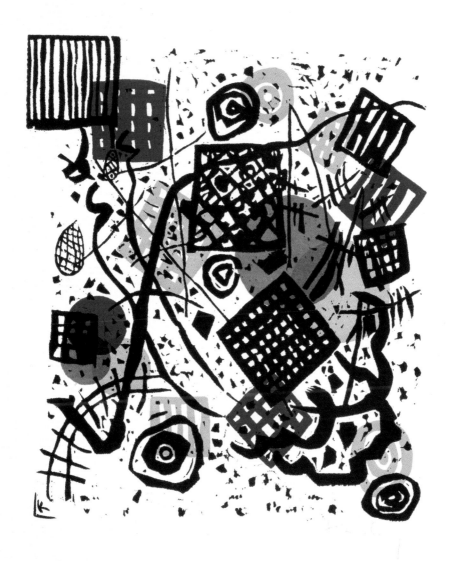

Wassily Kandinsky began his activity at the Bauhaus in Weimar in 1922. In the same year, works by Kandinsky were published in the printing workshop at the Bauhaus, under the title *Small Worlds*. He commented: "The *Small Worlds* ring out from 12 sheets." The illustration shows the color lithograph *Small Worlds V*.

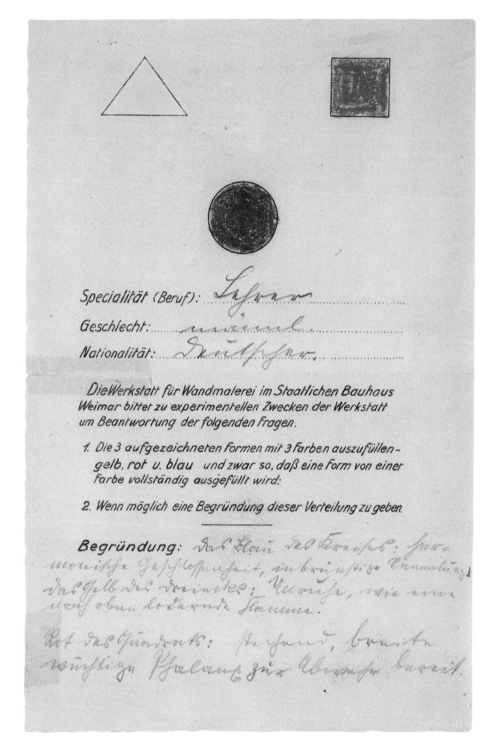

Specialität (Beruf): _Lehrer_

Geschlecht: _männl_

Nationalität: _Deutscher._

Die Werkstatt für Wandmalerei im Staatlichen Bauhaus Weimar bittet zu experimentellen Zwecken der Werkstatt um Beantwortung der folgenden Fragen.

1. Die 3 aufgezeichneten Formen mit 3 Farben auszufüllen – gelb, rot u. blau und zwar so, daß eine Form von einer Farbe vollständig ausgefüllt wird:

2. Wenn möglich eine Begründung dieser Verteilung zu geben.

———

Begründung: _Das Blau des Kreises: har-_
monische Abgeschlossenheit, inbrünstige Versenkung.
Das Gelb des Dreieckes; Unruhe, wie eine
nach oben lodernde Flamme.

Rot das Quadrats: strahlend, braucht
rauhigen Halkung zur Umwelt bereit.

Above all in the early Bauhaus days there was interest in various theories of color, for example those of P. O. Runge, A. Hölzel and Goethe. There was a discussion about which primary colors should be assigned to the basic forms, the circle, the square, and the triangle. In 1923, Kandinsky drew up this questionnaire, in which Bauhaus members were to assign colors to the firms. The majority of respondents decided in favor of this scheme. The yellow triangle, the red square, and the blue circle became a Bauhaus symbol and remain so today.

Runner rug by Gunta Stölzl, 1923. Stölzl, who began her studies at the Bauhaus in 1919, had taken her journeyman's examination in 1922 and from then on worked as a journeyman in the weaving workshop. In Dessau the weaver became the first female master at the Bauhaus. While the early Bauhaus carpets were often "pictures in wool," in Dessau it became increasingly important to develop functional fabrics as patterns for industry. But the "speculative confrontation with material, form, color in tapestries and carpets" was also of importance at that time.

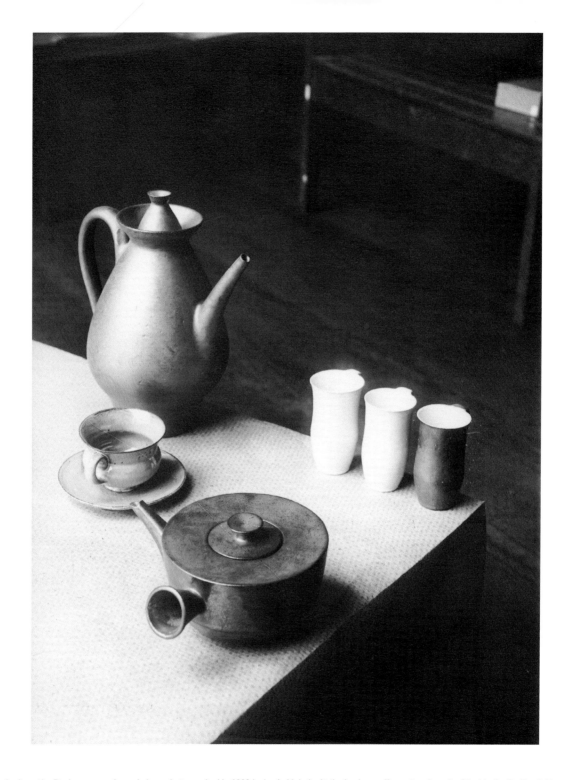

Works from the Bauhaus ceramic workshop, photographed in 1923 by Lucia Moholy. At the back, a coffee pot and cup by Otto Lindig. On the right, three cups by Marguerite Friedlaender. In front, a combination teapot with tubular grip by Theodor Bogler, which is reminiscent of Japanese teapots. Although the ceramic workshop was successful in producing handcrafted pieces as well as designs of types for industrial serial production, it was not continued in Dessau.

In 1923 Oskar Schlemmer took over the direction of the stage workshop. First, the students often worked out satirical and grotesque scenes. In the wake of the theme announced by Gropius in 1923, "Art and technology: a new unity," the relationships between man, technology, and machines also became a theme of stage work. The results included concepts of "mechanical stages" and, in 1924, the piece for dance and mime *Man at the Control Panel*, by Kurt Schmidt, for which he designed the stage set shown here.

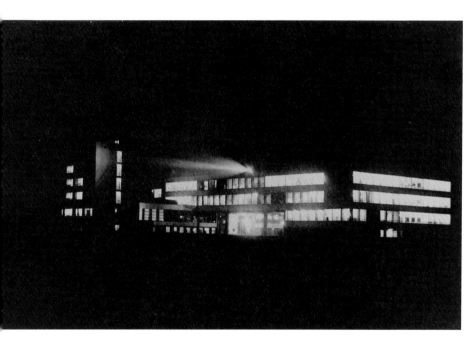

The Bauhaus building from the north-east at night, *c.* 1926.

seemed to float above its gray-painted, set-back concrete base. Tirelessly, the sun, light, and shade create new views of the building. At night, when the Bauhaus is lit from within, it even seemed to resemble a space ship. The idea for architecture of this kind did not come to Gropius overnight. As early as 1923 he described the nature of a new concept of building, which sounds like a precise characterization of this architecture: "We want to create buildings as clear, organic bodies, naked and radiant by virtue of their own inherent laws, free of falsehood and extravagancies, buildings that affirm a positive attitude toward our world of machines, cables and high-speed transportation, that disclose their sense and purpose of their own accord and through the tension created between the individual segments of their building mass, while rejecting everything superfluous that might obscure the absolute form of the architecture."

While before one could stand in front of a building and quickly grasp its form from this central viewpoint, here this was impossible. With this "jazz building," as Schlemmer jokingly called it, there seemed to be no front or back any more; in order to take in the whole building complex, one had to walk around it. In traversing this asymmetric complex, one observes the way in which the parts of the building sometimes seem to stand separately, each on its own, and yet sometimes join up again. The individual parts of the building stand for different functional areas. One workshop wing with the various workshops and teaching areas is linked to a connecting structure which houses the assembly hall. If one stands on the stage, the performance arena of Schlemmer's stage workshop, and opens the folding door that closes it off, one is already standing in the canteen. Thus these spaces can all be linked together as a "festive area,"

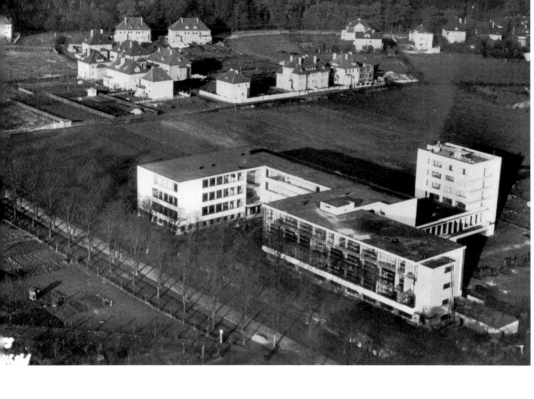

Bird's-eye view of the Bauhaus building in 1926. In the age of the aircraft, it was also important for the architect Gropius to know what effect a building would have from the air.

as Gropius called it. Behind the canteen is the Studio House, with twenty-eight residential studios for students and *Jungmeister*, with the rooms facing east having their own balconies. This spatial connection between the workshop wing, in which work is done, and the "festive area," where dining and celebrations take place, and the adjacent residential area, clearly expresses in architectural terms what was always the aim of community life at the Bauhaus: the combination of work, recreation, and life. Opposite the workshop wing, a commercial training college, independent of the Bauhaus, is accommodated—a condition imposed in advance by the city. The training college area and the workshop wing are connected by a two-story bridge across a street, a bridge on which the office and administrative spaces are housed. The workshops once again participated in the interior decoration of the whole building. The colorful decoration was designed by the new director of the wall-painting workshop, Hinnerk Scheper. The students in his workshop themselves painted the walls. The metal workshop

designed and produced a number of light fittings for the new building, a focal point which was to characterize this workshop during the Dessau period. The carpentry workshop made furniture designed by Breuer for the new house, some of which later became classics, such as the B9 steel-tube stools for the canteen.

The Masters' Houses

In Dessau, in addition to the new school building for the Bauhaus, Gropius had accommodation built for the masters. Not far from the Bauhaus building, in a small pine forest, the masters' houses were built within the space of a year, and were ready to be occupied by the summer of 1926. Gropius built three double houses for the masters and a separate house for the director—himself—with a garage for his newly acquired car. The double houses had the same ground plans, but half of each house was attached to the other at an angle of 90°. This serial and standardized character of the masters' houses was also a ruse on

Lyonel Feininger with his wife Julia in the studio of his master's house, 1927.

The masters' houses with the surrounding small pine forest, photographed by Lucia Moholy in 1926.

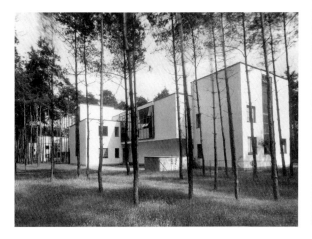

Gropius' part for saving money: "simplification by multiplication means price reduction and acceleration." But the white cubes did not give an impression of cheapness. Rather, they had the aura of elite villas, broadcasting the message: "Look, we have made it." It was exactly this effect that shocked Schlemmer, who wrote: "I had the impression that one day the homeless would stand here, while the gentlemen artists sunned themselves on the roofs of their villas." For Gropius, building meant the shaping of the processes of living: "the organism of a house results from the course of the events that take place in it ... the form of the building is not there just for its own sake, but springs solely from the nature of the building, from the function it is to fulfill." The furnishing of the houses left hardly anything to be desired. The latest technological and household appliances, such as a folding ironing board integrated into a cupboard, a dishwashing machine using soda, and a china cabinet that could be used on both sides, were part of the standard equipment. The wall cupboards, also accessible from both sides, and a built-in ventilator in the director's living room, gave a further impression of luxury. But what Gropius was trying to do was to get rid of life's unnecessary ballast in order to gain maximum independence from daily chores and so allow more time for intellectual interests. In 1930 he announced in a book about the masters' houses: "much that today still seems to be luxury will become the norm the day after tomorrow." But not all was comfort in these houses designed for artists—the large window areas of the studios caused the painters to shiver in winter. But solutions were found. Feininger placed a small coal-fired stove in his studio, and Kandinsky and Klee applied to the city for a heating subsidy.

The Experimental Settlement

As in many other areas of Germany after the First World War, there was an acute housing shortage in Dessau, especially for the workers who were continually arriving. The city, finding the presence of the Bauhaus opportune, commissioned Gropius to build a

The master of the wall-painting workshop, Hinnerk Scheper, with students, c. 1926.

workers' settlement. Everything was to be as economically priced as possible, and each house was to have a small garden and enough light, air and sun. In all, Gropius planned to build 314 houses of five different types. More individuality was unnecessary he believed: "The majority of individuals have similar necessities of life. Therefore it is logical and in the spirit of a commercial enterprise that these similar mass needs should be satisfied in a uniform and similar way. As a result it is not justifiable for each house to have a different ground plan, a different exterior form, different building materials and a different 'style.' This implies extravagance and a false emphasis on the individual ... Each individual is free to choose from among the parallel types ..." In order to save expense and time, materials were stored in grand style on the building site. Readymade elements for the houses were manufactured on the spot and a house was constructed from them at lightning speed with industrially manufactured steel windows. Soon

the workers were working so well together as a team that the shell of a building could be completed within six hours. The students too joined in the most varied areas of the work. The carpentry workshop, for example, built a complete furnishing arrangement, at first for a model house. However, though the Bauhaus furniture was clearly better value than that from the furniture stores, the occupants preferred to live with the furniture they had brought with them, and in quite an individual fashion.

Figures in the Laboratory

With its new location and new school building, there was much new definition, structuring and reorganizing at the Bauhaus, which now bore the title of "College of Design" (Hochschule für Gestaltung). Right at the top of the syllabus was a statement of the

A tea glass with porcelain saucer designed in 1926 by Josef Albers. The circular ebony grips for holding the glass are placed alternately horizontally and vertically.

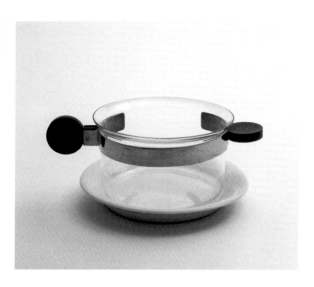

school's new purpose: "the thorough education of artistically gifted individuals in terms of crafts, technology and form, with the aim of cooperative work in building" as well as "practical development work for house building and furnishing, development of standard models for industry and crafts." And it was not only the syllabus that was suddenly being written in lower-case and unfamiliar spelling, but, from now on, all the official letters and documents issued by the Bauhaus. The Bauhaus itself explained the reason for this: "because in the use of language it is inconsistent to write differently from the way in which one speaks. we do not speak in capitals, so we do not write in them either ... and, when we think of the typewriter, the restriction to small letters means a great relief and saving of time."

In Dessau, the former masters became professors, a designation that had already aroused violent controversy at the masters' council in Weimar—after all, the Bauhaus had made it its aim to be as unacademic as possible. In addition there was an innovation: the ap-

pointment of so-called *Jungmeister*, or young masters, who brought a breath of fresh air to the teaching. They had studied at the Bauhaus in Weimar, partly gathered their first teaching experiences there, and thus absorbed Bauhaus influences from all sides. They were not specialists, but open-minded, versatile artists—genuine Bauhaus people through and through. As a result they were now entrusted with the entire direction of a workshop. The sharing of the director's role in the workshops between a form master and a work master thus became superfluous. Marcel Breuer was in charge of the furniture workshop, Hinnerk Scheper of the wall-painting workshop, Herbert Bayer of the newly structured workshop for

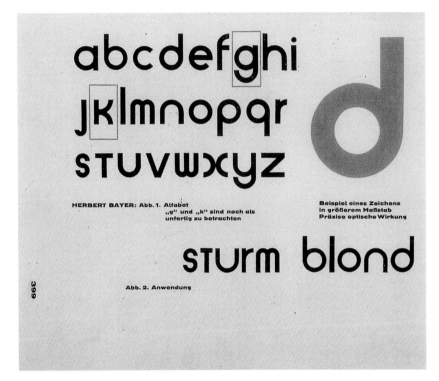

HERBERT BAYER: Abb. 1. Alfabet
„g" und „k" sind noch als
unfertig zu betrachten

Beispiel eines Zeichens
in größerem Maßstab
Präzise optische Wirkung

Abb. 2. Anwendung

399

Design for a new typeface by Herbert Bayer, 1926. By combining circle and straight line Bayer was trying to create a "synthetic" script.

printing and advertising, and Joost Schmidt later became director of a sculpture workshop. Gunta Stölzl, as the only female *Jungmeisterin*, and for that reason also maliciously nicknamed *Alibi-Meisterin*, took over the weaving workshop. Not all the workshops had moved from Weimar to Dessau, and so, apart from those run by the "young masters," there remained only the metal workshop run by László Moholy-Nagy and Oskar Schlemmer's stage workshop. Of course the preliminary course for all new arrivals at the Bauhaus was retained, but it was renamed the "basic course" (Grundkurs). Students no longer graduated from the Bauhaus by taking the journeymen's examination but by obtaining the Bauhaus' own diploma.

With the new direction "Art and technology: a new unity," Gropius had already begun in Weimar to give a new structure to the workshops. The division into teaching workshops and experimental and model workshops was not only continued in Dessau, but also expanded. Increasingly, prototypes, models, and patterns were to be developed and designed for industrial serial production. The beauty of it was that when an industrialist bought a student's design, it was not only the Bauhaus that benefited, but also the student. The designation "workshop" now hardly fitted this avant-garde field of experimentation any more. Gropius preferred to speak quite technically of "laboratories," in which the Bauhaus planned to "form a new, unprecedented type of employee who is master in equal measure of technology and form." There was as yet no proper name for this new professional concept. It was only several years later that the term "designer" was found for it. Design was

Students having fun in the
materials cupboards of
the Gropius architecture
department in the Bauhaus
building, photographed *c.*
1927 by Edmund Collein.

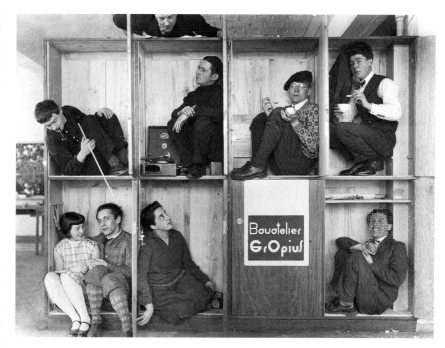

governed by a principle that Gropius had already formulated in 1925: "A thing is determined by its nature. To give it shape so that it can function properly—whether it is a container, a chair, or a house—its nature must first be studied; for it must fully fulfill its purpose, which is to perform its function in a practical way and to be durable, inexpensive, and beautiful."

In April 1927 an architectural class, the building department, was set up at the Bauhaus. The aim that had always existed in Weimar, but had never been adopted in the regular syllabus, was now at last a reality. Gropius appointed the architect thirty-eight-year-old Hannes Meyer, whose social commitment appealed to him as much as did his design for the Palace of the League of Nations in Geneva. In contrast to Gropius' original concept at the time of the foundation of the Bauhaus, students could go straight into the architectural department immediately after the preliminary course, without training in crafts in the workshops. Curiously, the teaching of architecture was always represented by a small class at the Bauhaus, which was never attended by more than ten students per semester. In the same year, Gropius introduced a further innovation at the Bauhaus: the so-called "free painting" classes. From now on, interested students could, in addition to their training in the workshops, participate in a painting class given by Klee or Kandinsky. The two painters were thus able to provide a certain balance in the face of the continuing mechanization at the Bauhaus, which they never tired of criticizing.

Gropius' Sudden Departure

By 1928 the Bauhaus had achieved much and was bet-

Hannes Meyer in 1928 during an inspection of a site on behalf of *Bundesschule des Allgemeinen Deutschen Gewerkschaftsbundes* (State School of the German Confederation of Trade Unions) in Bernau.

posed to any further hostility. Besides, he had for some time been tempted by the idea of working exclusively as an architect. In February, he submitted his resignation to the city. He had already found a successor: Hannes Meyer, from the architectural department.

"The needs of the people not the needs of luxury"

For the Marxist-oriented Meyer, the change of director at the Bauhaus was unproblematic. Gropius had not yet definitively departed when Meyer told the Bauhaus members in the spring of 1928: "Let us compare the Bauhaus to a factory: the director too is merely a worker, and a change of workers does not cause any disturbance to the whole."

One of Meyer's first actions was the devising of a new syllabus. The workshops themselves were partly reorganized. With the departure of László Moholy-Nagy, Herbert Bayer and Marcel Breuer the metal workshop was amalgamated with the wall-painting and furniture workshops and was now called the *Ausbauwerk-*

ter known than ever before. Enquiries from would-be students all over the world were coming in at the rate of up to 200 a week. But Gropius did not rest on his laurels. He traveled through Germany and abroad, gave lectures, won contacts, all in order personally to preach the Bauhaus concept. It was only in Dessau that these promotional tours had no effect. On the contrary. Here, as had already happened in Weimar, right-wing parties, supported by petty bourgeois citizens, railed against the Bauhaus. There were tensions even between Mayor Hesse and Gropius, the latter being difficult to contact because of his constant travels, and thus the animosities in Dessau were not easy to resolve. Gropius had been used to the severe criticism since the foundation of the Bauhaus, but the time had come when he no longer wished to be ex-

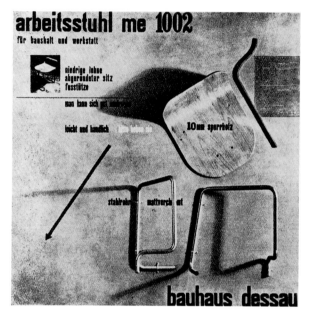

statt (construction workshop). It was headed by Alfred Arndt, who had studied at the Bauhaus and was already a freelance architect. For three days of the week, work went on in the workshops for eight hours a day, as much as in a factory. The workshops were now more directly concerned with production, which immediately became noticeable in the finances of the Bauhaus and of the students. Study in the workshops was now based on the commissions received by the Bauhaus. Meyer called this "productive education." He created a new motto for design and production at the Bauhaus "The needs of the people not the needs of luxury." Gone was the time of the individually designed component, the exclusive low-volume production, and luxury materials at the Bauhaus. Meyer was not concerned about "individually produced furniture for some 'Modernist' enthusiastic snob. But about unit furniture for the use of the people, the product of modern serial production, the product of the study of the customs of the people, social standardization, physiological and psychological functions, the stan-

dardization of the production process and the most careful commercial calculation," as he later recollected. Meyer carried out extensive scientific research into social needs in order to design objects corresponding to the "people" and their requirements. In this, he particularly had in mind the working classes and the minor employee, for whom he wanted to create better living conditions. Thus, need-based and inexpensive dwellings for the people were designed. Affordable furniture, which could be used in many ways, was made: a round table which could be folded, folding chairs covered in fabric, a work-stool with footrest, a cupboard with two usable sides on casters for bachelors, and a cabinet with drawers and a standard table, which could be transformed in the twinkling of an eye to a writing desk.

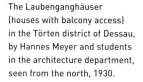

The Laubenganghäuser
(houses with balcony access)
in the Törten district of Dessau,
by Hannes Meyer and students
in the architecture department,
seen from the north, 1930.

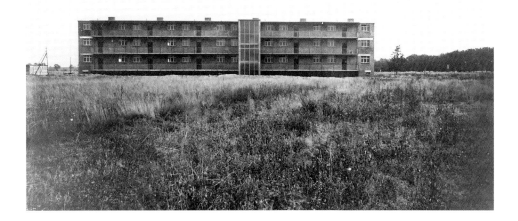

The final aim pursued by Meyer at the Bauhaus was the "summoning up of all living energies for the harmonious structuring of our society."

In 1929 Oskar Schlemmer, that master for whom humankind and its relationship with space stood at the center of his experimental work for the stage, left the Bauhaus. Despite revival attempts on the part of the students, there was never again a stage workshop at the Bauhaus. In the same year, however, the photography enthusiasts at the Bauhaus finally got a photographic department, directed by the photographer Walter Peterhans. For the architectural department Meyer had earmarked Ludwig Hilberseimer, who had already become known for books on the "New Building" and would soon also give seminars at the Bauhaus on residential urban construction. Soon after this, Klee announced that he had decided to take up a professorship at the Düsseldorf Academy of Art. In 1931 he left the Bauhaus, but kept his master's house until 1933. His former pupil, the *Jungmeisterin* Gunta Stölzl, wrote to him in farewell: "The strongly emotional riches of your formulas and the con-sistent, after all highly strict guidance of your works, has set a high standard for our active imagination ... You influenced us as both a human being and an artist ... We thank you!"

Collective Building at the Bauhaus

Meyer's most important educational rule was "study in a practical context." Under Gropius' direction, however, his work in the architectural department, for lack of commissions, had for the time being to remain theoretical. In 1928 the architectural department finally received a new commission. Rental apartments were to be built in the immediate vicinity of the settlement built by Gropius in the Törten district of Dessau. Meyer took his educational maxims seriously. The planning and construction management were taken over by a student collective, composed of students with varying skills. Five three-story apartment blocks were built in the traditional masonry style, and were ready for occupation by August 1930. Since the apartments could be reached by way of roofed exterior corridors, they

Aerial photograph of the *Bundesschule des Allgemeinen Deutschen Gewerkschaftsbundes* (State School of the German Confederation of Trade Unions) from the north-west, built after a design by Hannes Meyer.

were known as *Laubenganghäuser* (houses with balcony access). That the rent for the new apartments was extremely low was a cause for rejoicing, not just for the occupants, but also for the director of the Bauhaus: "... an apartment with two and a half rooms, with kitchen, bathroom and so on, for a rent of 37.50 a month! At last, a piece of work in the spirit of a new Bauhaus."

The largest and most important building project under Meyer was the building of a school for the German Confederation of Trade Unions (Allgemeine Deutsche Gewerkschaftsbund: ADGB) in Bernau, north of Berlin. Before Meyer created the design together with his students, he first observed the landscape. He closely studied the characteristics of the forest landscape at the intended site, which he wanted to include in his design. Then he analyzed the future function of the planned building, which was to be devoted to the further training of union officials. The results of this research served him as a starting point for the architecture, which he therefore called "scientifically based design." Almost at

the same time as the opening of the Federal School in May 1930, the criticism of Meyer's left-wing political activities grew ever louder. Soon after this, the city simply put "Red Hannes" out on the street. His payoff was made promptly and publicly. On 16 August 1930 a magazine published his vitriolic letter to the mayor: "How I was thrown out of the Bauhaus." The last words of his letter were: "... i see through everything. i understand nothing."

Mies' New Bauhaus Concept: "I don't want jam on it ..."

The new director of the Bauhaus, by the grace of the city, was the architect Ludwig Mies van der Rohe. He had been well known to the members of the Bauhaus since the Weimar days, before he became famous as an architect. It was above all his villas and country houses as well as his tubular-steel furniture that brought him fame. He had just built the German pavilion at the International Exhibition in Barcelona, known as the Barcelona Pavilion. The mayor chose Mies as

This 1932 design by the student Eduard Ludwig for a group of houses by the River Havel clearly shows the influence of the architecture of Mies van der Rohe.

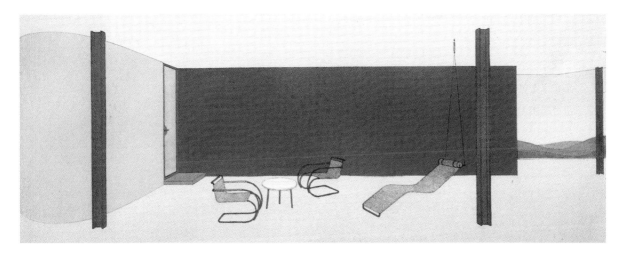

the new director because Mies was famous, and he wanted to have a non-political man at the Bauhaus again, in the hope of keeping the students' political activities in check.

On his arrival, the third Bauhaus director announced his new concept for the Bauhaus: "I don't want jam on it, not a workshop *and* a school, just the school." In the daily life of the Bauhaus this meant for a start that the workshops were scarcely an area for experimentation anymore and produced nothing, so soon the Bauhaus coffers were soon empty. Soon afterwards, therefore, the designing of models for industry was resumed, and income under license agreements rose. Nevertheless, the workshops now played only a subordinate role. Mies finally moved architecture into the center of training at the Bauhaus—without however creating a comprehensive connection to the other arts, as envisaged by the early Bauhaus program. Study was now strictly limited as to time, lasting only six rather than nine semesters as before. Students with previous knowledge were even allowed to study under him without taking the preliminary course. Soon the ratio of students in the architectural class to the other students was 3:1. Much of what was taught at the Bauhaus under Gropius and Meyer was moved to the background or disappeared entirely. Instead, the Bauhaus concentrated more and more on one person—the Bauhaus director. Mies was a strong personality who inspired respect. As a teacher, however, he was not a genius. The development and encouragement of the complexity and independence of the students was not his forte. He approved of those

Design of the student Rudolf Ortner for a one-family house taken from the architecture class by Mies von der Rohe, 1932.

who thought as he did, in a "Miesian" way. No wonder, therefore, that almost all his pupils' designs looked as though they could have been by Mies. At that time, there was hardly any opportunity for the architecture class to gather practical experience. The only project that could be observed by the students was the building of a small refreshment kiosk in Dessau to a design by Mies. The school had become a school of theory with high aesthetic aspirations, where there was no longer talk of "building" (*Bauen*) but of "architecture" (*Baukunst*). At the same time, discussions on teaching, criticism or analysis were not encouraged by Mies either. Again and again, the one-family house was the central theme in his teaching. He had a simple explanation for this: "If you can construct one of these houses properly, you will be master of all other architecture." If a pupil was dissatisfied with his work, Mies simply advised him to try again. And if it still was not right, the Bauhaus director without further discussion made a sketch himself, pushed it over to the pupil and said, "Try doing something like that."

The End

At the end of September 1932 the Bauhaus in Dessau had to close. Shortly before, the National Socialist Party in Dessau had demanded its dissolution. Since the National Socialists dominated the city council, the

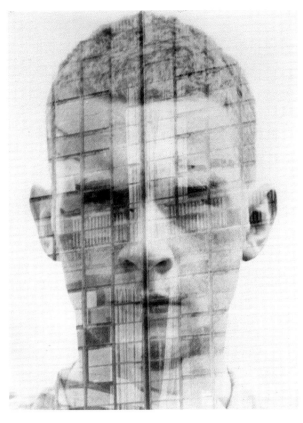

This photomontage the student Hajo Rose of 1930 simultaneously shows his self-portrait and the famous glass façade of the Bauhaus building.

majority of the people's representatives voted against the Bauhaus. But Mies did not want to give up the Bauhaus. He moved with his teaching staff, students, and a few tables and stools, to Berlin. Also in his baggage were the rights to the name "Bauhaus" as well as the existing license agreements and patents. Mies even arranged for the payments to the masters to be continued. His intention was to continue running the Bauhaus as a private institute in Berlin. But hardly had the group set themselves up to some extent in its new premises, a former telephone factory, than the storm troopers accompanied by the police were at the door looking for Communist materials, and locked up the Bauhaus. Mies tried everything to save the Bauhaus. He talked to the Nazi ideologist Alfred Rosenberg, the director of the Militant League for German Culture. Mies explained to him that the Bauhaus was so important for the future because it worked to overcome intellectually the problems arising from technology. Soon after that, a letter came from Dessau, where Mayor Hesse had been arrested at the behest of the National Socialist Party. In the letter it was stated that the city of Dessau was immediately discontinuing all payments to the Bauhaus masters—although these payments had been agreed by contract. At the same time, some of the patents lapsed. The future of the Bauhaus was bleak. With the additional constant political attacks, everyone at the Bauhaus sensed that *Gleichschaltung* (enforced conformity) was only a question of time. Thus, on 19 July 1933, the teaching staff decided unanimously on the final closure of the Bauhaus.

Paper folds such as these by Alphons Frieling of 1929 are typical examples of sculptural material exercises with paper from the preliminary course conducted by Josef Albers. Albers challenged his students to experiment in creating a form making full use of a material's particular qualities, without loss of material, and with the highest precision. The students' skill counted for more here than the aesthetic result. He explained to his students: "Every piece of art consists of its original material, this is why we have to analyze first what this material is made of ... You have to keep in mind that you are often more successful by doing less."

László Moholy-Nagy was convinced that modern man's sense of touch was increasingly weakening. He gave particular importance to training in the sense of touch, as it was the precondition for good visual perception. Thus, tactile charts and tactile panels were created, such as those shown here from 1928 by Otti Berger, who fixed fabrics and threads of various qualities on wire netting, and placed various small cardboard boxes in the "pockets" created in this way.

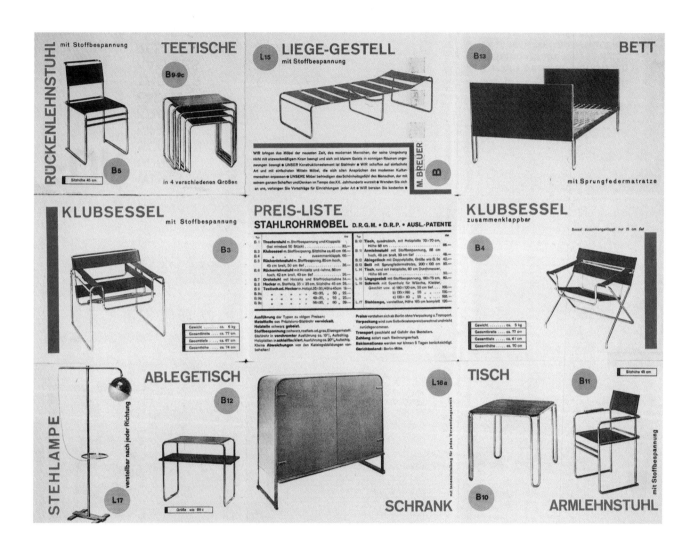

In 1928 Kálmán Lengyel designed this flyer for "standard furniture." He presents tubular-steel furniture by Breuer (B numbers) and Lengyel (L numbers). Apart from other things it shows the seat "B3" that is also called the "Wassily Chair," because Kandinsky is thought to be one of the first to own one. Today it is a real icon.

Production photograph of Oskar Schlemmer's *Metalltanz (Metal Dance)*, first performed in 1929, with the dancer and gymnastics teacher Karla Grosch. In principle, any Bauhaus member could participate in the stage work under the direction of Oskar Schlemmer—no matter in which workshop he or she was being trained. But one could not graduate separately from this class. In his stage work at Dessau, Schlemmer wanted to explore the `elementary' and `fundamental' laws of the reciprocal relationship between man and his surroundings. The work had the character of dance or mime and predominantly renounced the use of speech.

Around 1929, Joost Schmidt designed various versions of the letter P in these nine squares. It was a regular part of Schmidt's teaching that the students should present a given theme in nine variations in the boxes of three times three squares. Schmidt's intention was to convey to the students that there is never only one solution to an imposed task. This creative method helped to think in alternatives and created diverse expressions.

In 1928 László Moholy-Nagy prophesied that "not the person who cannot write, but the one who cannot take photographs will be the illiterate of the future." In 1929, a photography department was set up at the Bauhaus. However, before this almost every other Bauhaus member in Dessau was taking photographs, on their own initiative. This still-life with its contrast-filled composition, in which the materiality and surface structure of each object is brought out, is typical of the aesthetic of Walter Peterhans, who directed the photography class.

Particularly in the early days of the Bauhaus at Weimar, but also in Dessau, many of the masters and students became involved in the most varied esoteric trends. In 1931, for example, Joost Schmidt included in his teaching the concept of the *chakras*, the so-called energy points of the human body, which among other things are part of the spiritual teachings of yoga and Tantric Hinduism. The sheet shown here, from 1931, comes from Schmidt's preparatory teaching notes and shows the seven *chakras*.

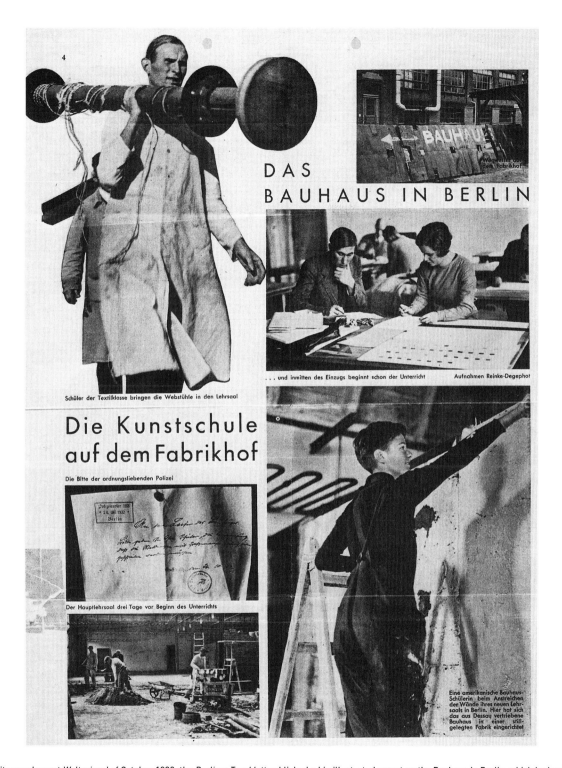

In its supplement *Weltspiegel* of October 1932, the *Berliner Tageblatt* published a big illustrated report on the Bauhaus in Berlin, which had only recently moved to the site of a former telephone factory in the Steglitz district of Berlin.

Life

"the atmosphere of the Bauhaus cannot be described in a few words ... above all it seems to me to be determined by an extraordinarily strong urge for freedom ... an urge for freedom in which it is generally not a question of freedom 'from what,' but of 'for what'."

Hanns Riedel, 1929

The Private Lives of the Bauhaus Masters

At the Bauhaus many noted artists became colleagues. In private life, too, many friendships arose among the masters. They often visited each other with their partners and children. Sometimes they also spent leisure time together on trips and outings or on holiday. Let us cast a glance over the private passions, peculiarities, and preoccupations of the famous avant-garde artists.

Lyonel Feininger on his bicycle in Dessau in 1928, photographed by his son, Andreas.

"The fact that I am still a student of the Bauhaus today proves that the world only makes sense if it is a Bauhaus. The whole world is a Bauhaus."

Fritz Kuhr, 1928

By Racing Bicycle, on Foot, and by Carriage

Riding a racing bicycle in the great outdoors was one of Wassily Kandinsky's favorite leisure occupations. Both in Weimar and Dessau he went on frequent cycling tours with his wife Nina. Lyonel Feininger was also an enthusiastic cyclist, who toured the environs of Weimar and Dessau on his old "Cleveland" looking for subjects for his paintings. Paul Klee was a passionate walker. With his characteristic hesitant gait, he daily explored the town and nature. The Kandinskys and Klees regularly traveled by carriage to the Wörlitzer Park, one of the most important European landscape parks outside the gates of Dessau.

Paul Klee proudly presents
the front-door key of his
new master's house.

Musical Masters

Papileo, as Lyonel Feininger was affectiona-
tely nicknamed at the Bauhaus, played not
only violin and organ, but also composed
music. During the time at the Weimar Bau-
haus he produced several fugues for organ
and piano that revealed his enthusiasm for
Bach. Paul Klee was a virtuoso violinist, who
often practiced for several hours a day.
Sometimes he gave a concert for the stu-
dents and masters. Together with his wife
Lily, a pianist, and his Dessau neighbor Lyonel Feininger, he put on musical soirées, where Bach and Mozart
were played with abandon. László Moholy-Nagy, who liked only contemporary music, on the other hand did
not play any traditional instruments. Like disk jockeys much later, he experimented with gramophone
records: he let them play backwards, scratched them, and scored them with nails, in order to lure new sound
effects out of them.

The Masters and Their Very Individual Homes

The designs of the masters' houses form a stylistic unity.
But the masters and their families furnished these houses
very individually, and partly in contrast to the architecture.
While László Moholy-Nagy preferred simple forms and Bau-
haus furniture, Lyonel Feininger and Paul Klee also loved an-
tiques. Wassily Kandinsky collected Indian sculptures and
Russian icons. Was it with delight or horror that Gropius noted
on the masters' interior decoration "the divergent treatment
in the use of color and the furnishing ... despite the similarity
of the ground plans produces such a diverse effect that the
observer is not aware of the identical designs of the rooms in
the different homes"?

Gropius' Most Beautiful Cactus: a Cucumber with Radishes

Gropius, also known as Pius to the Bauhaus
members, was a passionate collector of cacti.
On many weekends, he would drive out from
Dessau to small market gardens in the area in
search of beautiful and rare cacti. He converted
the windowsill in the living room of his master's
house into a cactus nursery, and on his terrace
a series of little pots of cacti stood in a row. His
most beautiful cactus, according to Marianne
Brandt, was a birthday present from a Bauhaus
member: a green cucumber, with carved rad-
ishes as flowers.

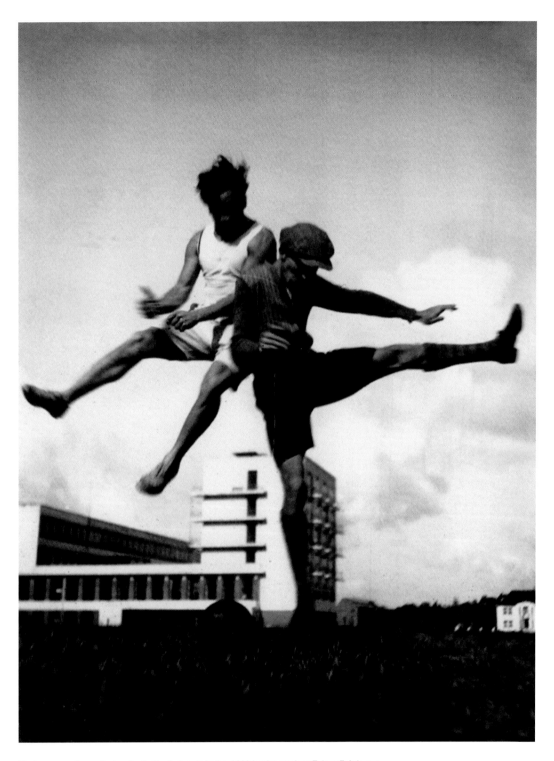

Bauhaus members playing football, photographed *c.* 1929 by the student T. Lux Feininger,
the son of Lyonel Feininger. He took many extraordinary pictures of the life at the Bauhaus.

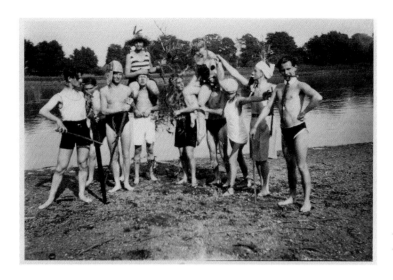

Bauhaus members enjoying a bathing trip at the Elbe, with the usual teasing, clowning, and great fun, photographed in 1928 by Edmund Collein.

Freedom, Celebration, and Arrests

For many of the Bauhaus members—the *Bauhäusler*—life was more important than their work at the Bauhaus. Many of them, such as László Moholy-Nagy, did not even differentiate between work and life—they merged into one.

Sleeping Rough and Begging Letters

One thing united all these very different students in a time of hunger, inflation, and political unrest: outright poverty. Not all of them had somewhere to live, and some would occasionally spend the night on a park bench, for example the young Otto Umbehr, later to become world-famous as the photographer Umbo. Many earned a few marks as extras at the Weimar Theater, others produced series of Thuringian "peasant paintings" for a firm. With fatherly concern, Gropius wrote countless letters to institutions and well-to-do private individuals asking for food and money for an endowment fund

> **"The students I have seen so far look very self-confident ... this is a new breed of mankind, a new generation."**
>
> **Lyonel Feininger, 1919**

Invitation card by Ludwig
Hirschfeld-Mack to the kite
festival of 1921 or 1922.

that he had set up for needy students. In a letter of 1921 to the Dresden art collector Ida Bienert he wrote: "The living conditions of our apprentices are such that our whole enterprise will be placed in doubt if their poverty is not relieved." In the end, Gropius came up with the idea of founding a "Bauhaus National Lottery" in order to salvage the financial situation. The first prize would be a house designed and built by the Bauhaus! But for bureaucratic reasons this idea came to nothing, so that, despite the generosity of some of its patrons, the financial situation for the Weimar *Bauhäusler* never greatly improved.

"I'm sending you to the Bauhaus!"

In Weimar, the bourgeois city of Goethe and Schiller, the *Bauhäusler* were out of the ordinary, if only because of their appearance. Some of the male students had long

hair, while several of the women sported an ultra-modern bobbed hairstyle. They hardly ever wore stockings, and their wild mixture of shabby clothing provoked some upright citizens to such an extent that in 1920 Gropius found himself obliged to organize a large delivery of clothing from army stocks. From then on, many of the *Bauhäusler* were seen around in soldiers' uniforms, which they revamped and dyed to suit their own personalities. Their longing for freedom and their anti-bourgeois attitude was also expressed when they went swimming: both male and female students were repeatedly seen sunbathing on the banks of the Saale entirely unclothed. The result was a flood of complaints from Weimar citizens about this "outrage against public decency" and "public scandal." Gropius then wrote to the ministry of education and cultural affairs that "the Bauhaus has the

The Mazdaznan teaching included a special diet, fasting and cleansing regimes. In 1922 Paul Citroen illustrated these methods: evacuation via mouth and bowel and the stimulation of the skin, in order to improve the metabolism.

character of a university, so that the masters have no direct influence on the students' behavior." It was at this time that recalcitrant Weimar children began to be angrily threatened: "I'm sending you to the Bauhaus!" Certainly, the colorful Bauhaus tribe would not have caused as much of a scandal in Munich or Berlin. But Gropius was sure that at this stage the school would have been endangered by the chaos of a big city. In a letter of 1923 he wrote about the importance of the small city of Weimar for the great Bauhaus experiment: "A small, quiet spot is necessary to make possible the communal work of the participants among each other."

Secret Teachings

At no point were the Bauhaus discussions about an appropriate lifestyle more diverse than during the Weimar years. Esoteric and philosophical ideas were intensively discussed and practiced, accompanied by mutual criticism and quarrels. Probably the greatest ideological influence was exercised by the teachings of the Mazdaznan movement, which entered the Bauhaus with Johannes Itten, supported by Georg Muche. This "life-skill" movement, founded by Otto Hanisch (who called himself Otman Zar-Adusht Ha'nish) in America in the late 19th century, was supposedly based on the "secret teachings" of the ancient Persians, Greeks and Egyptians, and aimed at achieving spiritual perfection. Its essential elements were a special system of body care, breathing exercises, and a vegetarian diet. In the end it was only a small but steadfast circle that practiced the Mazdaznan teachings out of devotion to Itten. They were recognizable by their clothing, which soon became known as the "Bauhaus costume." The men wore simple monochrome smocks, fastened with a belt, and trousers that were tight lower down but loose at the top, and the women a shapeless over-garment. But Itten

Lyonel Feininger designed this postcard for the Bauhaus festival of lanterns in June 1922.

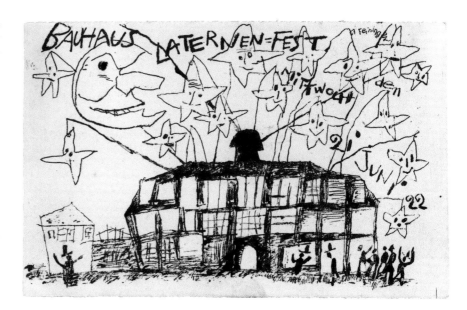

reached all the students with some of his exercises, such as the Mazdaznan breathing exercises, which he built into his preliminary course. It was his aim to cultivate a new human type by means of changes in thought and feeling. In addition, in 1920 he introduced a vegetarian cuisine for all in the Bauhaus canteen. Since the Mazdaznan diet was based on quantities of fruit and vegetables, and food was expensive and in short supply, a special Bauhaus garden was laid out, which was tended by the students. This garden, which Gropius was able to rent after pawning some valuable objects from his family estate, was intended to be part of a planned settlement for the *Bauhäusler* and their friends—but this never came to pass. With Itten's departure in 1923, Mazdaznan ideas too left the Bauhaus, and the Bauhaus tribe mockingly struck up the so-called Bauhaus cat-call: "Itten Muche Mazdaznan, now at last they've gone, they've gone ..."

The Bauhaus Barometer

Life at the Bauhaus did not end with the end of classes. Gropius' ambition to form a community not only of work but of life was reasserted in the Bauhaus program: "Cultivation of friendly association between masters and students outside the work context; in addition, theater, lectures, poetry, fancy-dress parties, a structure of light-hearted ritual at these social occasions." Masters and students went rambling together, met at the most diverse performances by guests at the Bauhaus, or for reading groups at Gropius' house. Together they read about the architectural fantasies in glass of Paul Scheerbart, or discussed the poems of Walt Whitman or Chuang Tse, all the while munching peanuts from Gropius' endless supplies.

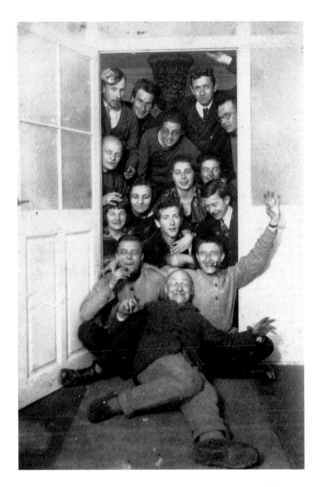

One big happy family: teachers, students, and guests at the Bauhaus in Weimar, *c.* 1923.

Above all, the Bauhaus was a place for parties. "From the start, and throughout the years that followed, parties were the barometer of the Bauhaus," wrote Gunta Stölz, looking back on her time at the Bauhaus. In Weimar, the *Bauhäusler* put on a celebration for every season of the year: a festival of lanterns in the summer, and later a solstice festival. October was the time for the kite festival, with fantastic, bizarre flying objects constructed by the students, and then came Christmas. On 18 May, the Bauhaus always celebrated the birthday of the "Silver Prince," as Paul Klee called Gropius after their first meeting. Even the completion of a particularly successful workshop piece was celebrated, as the master Lothar Schreyer recalled: "When Ida Kerkovius had completed her first large carpet in the weaving shop, we celebrated in my small apartment ... This fine impressive carpet, measuring more than five square meters [43 square feet], almost filled the entire room. We had framed it with burning candles and squatted around it on the floor, enjoying it with cheerful soft-spoken talk ..."

For some parties, the costumes were so unusual that in 1924 the journalist Kole Kokk remarked that "the sensational quality and blazing colors" of the costumes far surpassed anything to be seen in Berlin at the time. What did the costumes at these weird, extravagant parties look like? Wassily Kandinsky came to one as an antenna, Itten as an amorphous monster, and Gropius disguised himself as Le Corbusier. Lyonel Feininger daringly appeared as two right-angled triangles, while Muche partied in the guise of an unwashed prophet. Klee enchanted his observers as the "song of the blue tree." Sometimes the stage workshop put on experimental works and sketches in which not infrequently everyday life at the Bauhaus was parodied.

Party for the naturalization of Wassily and Nina Kandinsky in 1923. Kandinsky dressed incongruously in Bavarian lederhosen and a tail coat, while his wife wore a garish tulle dress.

Every Saturday, masters and students met for uninhibited dancing. Then everyone would dance the wild "Bauhaus dance" which they themselves had created, accompanied by the students' band, whose fame had spread far beyond Weimar. Played on unconventional instruments, a wild and highly unusual mixture of eastern and southern European folk music was blended with waltzes, marches and tangos. In 1925, shortly before the move to Dessau, the last Weimar Bauhaus party took place. It was christened the *Kehraus-Fest*, or grand finale party.

The New Bauhaus World of Dessau

The move from Weimar to the more industrialized city of Dessau in the spring of 1925 was at first not easy for many *Bauhäusler*. Oskar Schlemmer, for example, wrote of his first impressions of the new Bauhaus city: "Everything so bleak and dreary. No life." The students and masters moved into temporary workshop and stu-dio spaces in Dessau, and the decisive point was reached on 4 December 1926, with the opening of the Bauhaus building. In Dessau, the life and work of the *Bauhäusler* suddenly became more transparent, for a new permeability became part of the program. The glass curtain-wall of the workshop wing allowed continuous views from outside of the *Bauhäusler*'s work, and conversely they too had a view of their immediate environment on the outside. Free time for the students, a quarter of whom came from abroad, was rare. Often classes lasted from seven in the morning until nine in the evening. At weekends, many were attracted to the banks of the rivers Elbe and Mulde, or to the

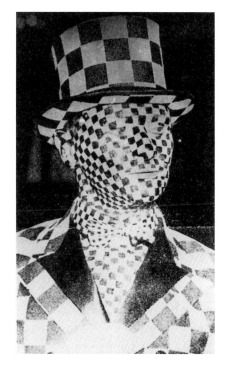

The weaver Lis Beyer in her room in the studios, *c*. 1929. Her "roommate" made out of paper might be a model or might be also a "surprising guest" for the next Bauhaus party.

The student Heinrich Koch dressed up as a checkered visitor at the "White Festival."

theater or cinema, where their objects of admiration were Buster Keaton and Charlie Chaplin.

Some *Bauhäusler* now lived in the specially provided studio house. This too was unprecedented—no other college or university in Germany had an integrated students' home. And at night, a number of students pursued a private passion in their rooms—painting. In 1929 the *Bauhäusler* Ernst Kállai tried to interpret this phenomenon: "painting is able to open up deep human sources and emotional values, which are of immense importance precisely in the context of the necessary rationalism of the building and *Zweckform* discipline at the Bauhaus."

"Emotional, Epochal, and Normative"

The great costume parties, often weeklong, at Dessau became famous, sometimes conducted by the stage workshop and Schlemmer, sometimes by László Moholy-Nagy as well as Josef Albers and the preparatory course students. In March 1926 the Bauhaus issued invitations to the "White Festival" with the motto: "2/3 white, 1/3 colored;

stippled, diced and striped." The program announcement promises "the emotional, the epochal and the normative, weaving in the forest, p-p-poetry, uncle lala in the schoolyard and a criminal symphony." So that all the masters could hold their own as dancers at these parties, Ise Gropius sometimes hired a dance teacher from Berlin. Furnished with a gramophone, he held intensive courses in the latest dances such as the Charleston. But this sort of enterprise sent Klee and Kandinsky, who disliked parties, into a rage. In 1928 a carnival party was held, which was so successful that another party was immediately organized in Berlin with the same motto: the "beard, noses and heart party." For this event a costume advice center

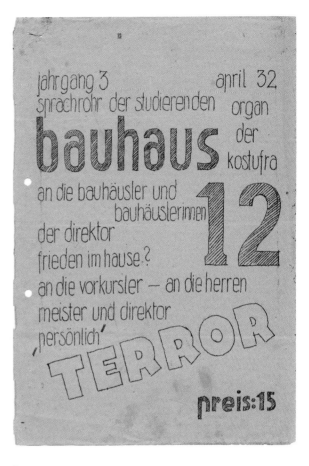

was specially set up, and the party included a "hair-dresser's salon" with home-made wigs and beards as well as a "photography booth" where one could have a portrait taken by the photographer Umbo. The last great party at Dessau was the "Metal Party" with the subtitle "bells, jingling, tinkling party" in February 1929. On the invitation card, gentlemen were invited to come as an "egg-whisk," a "metal salt or pepper mill," "can-opener," or even "lead soldier." Suggestions for ladies were to appear as a "diving bell," a "bolt or wing nut," or perhaps a "radioactive substance." And the Bauhaus building transformed itself for this party—the glass façade was covered with metal foil and visitors traveled to the party by way of a metal slide. Above the sliding guests there dangled a hundred glittering silver glass spheres, which reflected everything in a fantastically distorted image. The theme was continued in the food and drink, with metallic-tinted cakes and appropriately named drinks, "Goldwasser" liqueur, "Kupferberg Gold" sparkling wine, and "Nirosta schnapps."

"The Red Bauhaus"

While at Weimar the political activities of the *Bauhäusler* were only occasional, and specifically prohibited by Gropius, in Dessau the increase in leftist-oriented students resulted in greater politicization of Bauhaus life; in 1927 a Communist cell was founded at the Bauhaus. Many members of this circle joined the German Communist Party and gained a number of sympathizers within the Bauhaus itself. They often took part in demonstrations, protesting against the USA's execution of Sacco and Vanzetti or against the building of armored battleships. The students' protests were sometimes quite artistic and turned into agitprop theater on the Bauhaus stage. Among the population of Dessau the Bauhaus was already known as "the Red Bauhaus." The new director, Hannes Meyer, at once began to offer, as part of the lecture evenings, introductions to Marxism-Leninism and

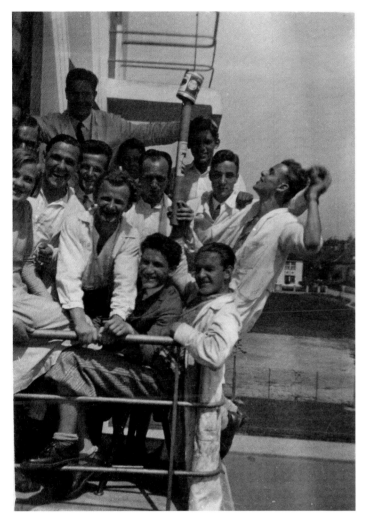

Students, *c.* 1932, on a balcony at the "Prellerhaus," which at that time was no longer used for residential purposes. For reasons of space, the rooms were now used as studios.

lectures on the history of the German workers' movement. He supported and strengthened the Communist views of many of the students. In the end, he was admonished for this by the Social Democratic mayor of Dessau, Fritz Hesse, which led to Meyer's dismissal without notice in the summer of 1930.

As new director, Mies van der Rohe tried to prohibit the students' political activities by means of dismissals and bans from entering the building, but with only partial success. Thus the Communist student faction kostufra (an acronym formed from Kommunistische Studentenfraktion) distributed its own magazine in the Bauhaus from 1930 to 1932. While the leftists in the Bauhaus had once reproached Gropius over the luxury goods produced there, Mies was now criticized for building dwellings for rich people. But the rest of the student body was not apolitical, either. In the center of social life at the Bauhaus, where Max Ernst's graphic novel *La femme 1000 têtes* and the leftist magazine *Die Weltbühne* were read, the seating order suddenly became an expression of the political sentiments of the students. The student Hans Keler wrote in October 1931: "The room is divided into four large rows of tables. At the first table sit the undecided ones ... at the second and third tables the opposition, the second directed more to the right, the third more to the left, and at the fourth were the radicals." At this politically highly charged time, when any scandal might harm the Bauhaus, all the students received a letter from Mies before the beginning of the semester, which was to be signed and returned to

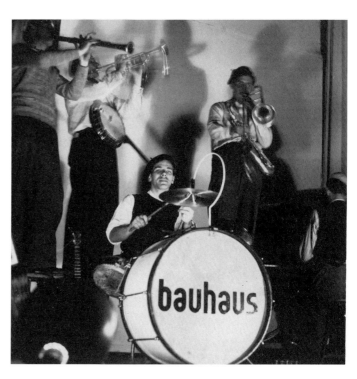

The Bauhaus band in 1931. The band was very well known and popular, and was therefore also a fantastic advertisement for the Bauhaus.

the Bauhaus: "I undertake ... to take part regularly in the courses, not to sit in the canteen after the meal is over, not to spend time in the canteen in the evening, to shun and avoid political discussions, to refrain from making a noise in the town, and to go out properly dressed ..."

Nazi Horror and a Last Boat Trip

In the winter of 1932, after the forced closure in Dessau by the National Socialists, a former telephone factory building in the Berlin district of Steglitz was converted. While some of the *Bauhäusler* tore down walls, others built new walls, so that the building could be used as soon as possible for a new school. Early in 1933, in this situation of political and financial difficulty for the Bauhaus, the success and energy of the old parties was recalled, and in February a costume party was organized. Mies, Albers, Kandinsky, and Peterhans designed rooms specifically for this purpose. A lottery offered the chance to win works by Feininger, Kandinsky, Klee, Georg Kolbe, Emil Nolde, Pablo Picasso, and others. The party, with 700 guests, was such a success that it was repeated the following week.

Barely two months later, the Berlin Bauhaus was raided by the SA, the Nazi storm troopers, searched for Communist propaganda materials, and then locked up. Probably no one suspected that classes would never be resumed. A group of students who had no identity pa-

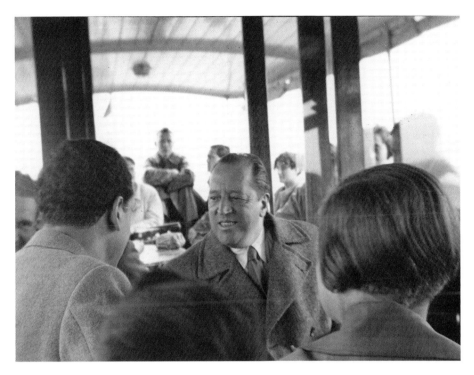

Mies van der Rohe in May 1933 on his last outing with his students.

pers on them were taken away and released from custody two days later. Although Mies fought for the continuation of classes, at the beginning of May the Bauhaus was still closed. In this situation, Mies organized excursions for the Bauhaus community, renting a boat to take the students to see the fruit trees in blossom, and to Paretz in Brandenburg, where David Gilly, a student of the architect Ludwig Persius, had a small *schloss*. Then he organized a trip to a travertine quarry, where this stone, so much prized by him, was mined. Next he proudly led the *Bauhäusler* through one of his latest houses. Here life and work merged for the last time. On 15 June 1933, the Bauhaus finally closed its doors.

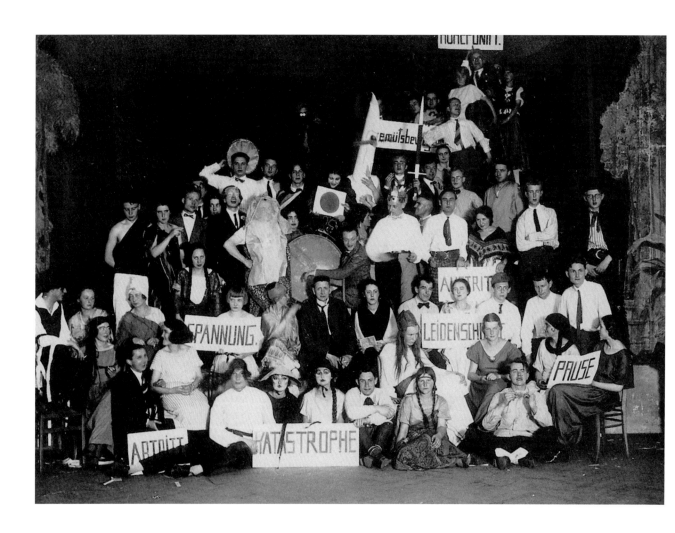

Bauhaus members at a Bauhaus party in the Weimar restaurant Ilmschlößchen in June 1924. It was positively a ritual at such parties to dance the "Bauhaus dance," which they had invented themselves. It involved dancing in couples without touching each other, sometimes in leaps, sometimes with a spirited, wild stamping of feet. When it seemed that the sense of community at the Bauhaus in Dessau got lost, the students remembered this dance from the Weimar times and everything was right again.

Xanti Schawinsky (front right) and other Bauhaus members at the "White Festival" in March 1926. Ise Gropius noted in her journal about this event: "Various altars had been built on the gallery, a directors' panopticum, etc.; very amusing ideas, constructed with endless effort ... The specific watchword for the festival resulted in a very uniform picture; I cannot remember a festival with more beautiful masks."

This collage, designed by Herbert Beyer in 1926, was a collective birthday card from a number of Bauhaus members to Walter Gropius on his 44th birthday. With its many individually signed kisses and cheeky comments such as "Hairs in unwelcome places," "Endearments" or "Every hour," it was at the same time a special declaration of love. Does this card not say more than a thousand words could about the liberal atmosphere at the Bauhaus at that time, and the unique relationship between its members and their director?

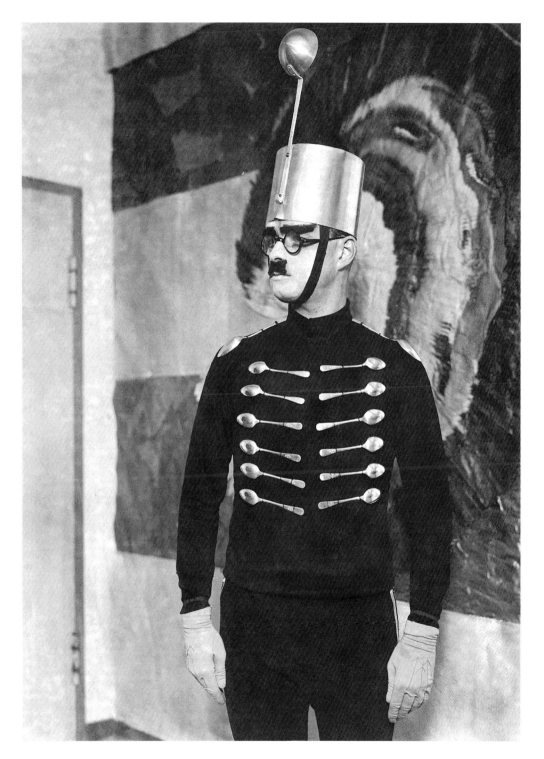

"A death's-head hussar in black, with an aluminum pot and riveted spoon as a helmet, his chest adorned with silver spoons," wrote Oskar Schlemmer in enthusiasm over this unknown guest at the "Metal Party" that was held at the Bauhaus in 1929. For Schlemmer this "Nonsense Soldier" was one of the best costumes of the evening.

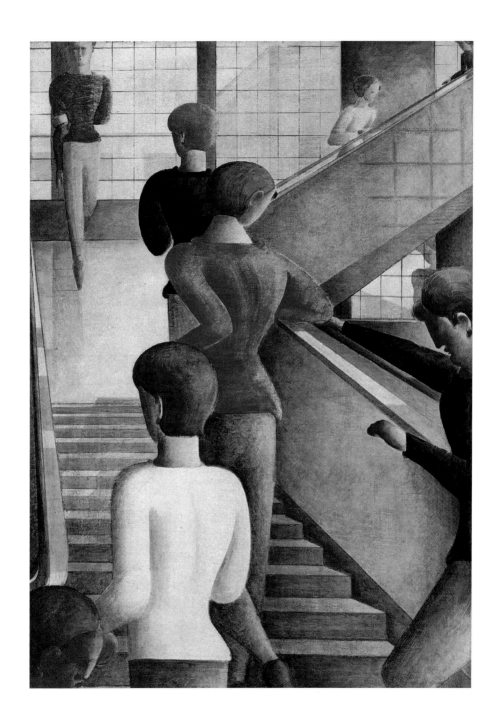

In 1932, several years after Oskar Schlemmer had left Dessau, he received the news of the imminent closure of the Bauhaus. Deeply shocked, Schlemmer began work on the painting *Bauhaustreppe (Bauhaus Stairway)*, in which he once again took up the aims of the Bauhaus's foundation as an artistic theme: the new human being and the new architecture, which here achieve unity. At the same time it is a homage to the Bauhaus building at Dessau, with its stairwell and the workshop wing, which is seen through the window. Later Schlemmer considered it 'perhaps my finest picture'.

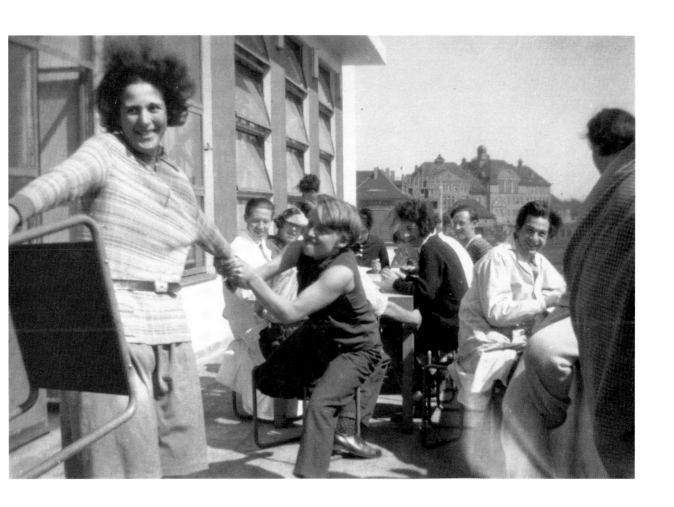

Break-time fun on the terrace in front of the refectory at the Bauhaus building, *c*. 1929. In the center, fighting, Karla Grosch, the ladies' gymnastics teacher at the Bauhaus, who also took part enthusiastically in the work of the Bauhaus stage productions. Grosch, who had studied with the dancer Gret Palucca, began teaching in 1928, when Hannes Meyer first included sport in the Bauhaus curriculum.

Love

"... we, the people of today, have simply not yet found the formula for love and marriage, and the same search that is expressed in all our works is the desperate yearning for a new life form ..."

Gunta Stölzl, 1920

Red Men and Blue Women

What was proclaimed in the Bauhaus programs, manifestos, and brochures sometimes seemed to be more of an ideal, which often failed in everyday life. The equality policy remained more of a publicity-conscious wish than a consistently fulfilled promise. Nevertheless, male and female students mingled in an atmosphere of unprejudiced collegiality. Meanwhile, in the classrooms the question was discussed as to whether men were red and women blue, whether they were angular or spherical ...

Blue, Spherical, Feminine

Which basic geometric form corresponds to the male and which to the female principle, and which colors correspond to them? Johannes Itten was the first master at the Bauhaus to announce, in his preliminary course, that the circle corresponds to the female and to the color blue. He assigned the square and the color red to the male. Wassily Kandinsky decided to test Itten's claim in 1923 by means of a questionnaire that he distributed at the Bauhaus. The majority confirmed Itten's theory, which was also supported by Kandinsky. This allocation of basic forms and colors then infiltrated many works created in the workshops.

Bauhaus members
Georg Hartmann,
Naftaly Rubinstein,
Myriam Manuckiam (Koko)
and Günter Menzel.
Photographed c. 1929
by T. Lux Feininger.

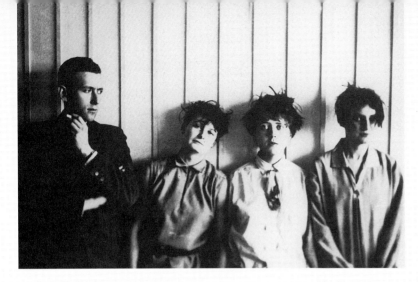

Marcel Breuer in 1927 with his "harem," the Bauhaus members Martha Erps-Breuer, Katt Both, and Ruth Hollós (from left).

"as a woman student, do you seek true equality?"

In the very first Bauhaus prospectus Gropius wrote in the conditions of entry that "all persons of good character without discrimination of age or sex" could attend the Bauhaus; the only decisive factor would be talent. In another place Gropius declared that women and men would have the same rights, but also the same duties at the Bauhaus. Meyer, the second Bauhaus director, deliberately used equal rights as a selling point. In one prospectus of 1929, under the motto "young people, come to the bauhaus!" are the words: "as a woman student, do you seek true equality?"

The women's class

While in the first semesters all the workshops at the Bauhaus were open to all students, in 1920 Gropius set up a so-called women's class, which soon merged with the weaving workshop. The reason given for this was that the often physically demanding work in most of the workshops was unsuitable for women. However, many stubborn women nevertheless worked in other workshops. On the other hand, men repeatedly managed to find their way into the weaving workshop.

A Brief History of Gender at the Bauhaus

Compared with other art schools at the time, the Bauhaus in its early years had an unusually high proportion of women students. In the winter semester of 1919–20 there were almost exactly as many young women as men at the Bauhaus. One year later, out of a total of 143 Bauhaus members, 62 were female and 81 male. After this the proportion of women steadily decreased. In the Dessau period, the number of women students made up on average only one-third of the total. The Bauhaus in Berlin had the fewest women.

Abortion painting at the Bauhaus

In 1931 an exhibition by the painter Werner Scholz was put on in the Bauhaus building. Among the exhibits was a painting with the theme of abortion in Germany. Mies, finding it "distasteful" and "offensive," had it taken down. The leftist members of the Bauhaus, above all, who had a serious quarrel with section 218 of the penal code, which prohibited free abortion, interpreted the ban as symptomatic of a direction and an attitude "which are cursedly similar to those of the nazis." These students admittedly also had another criticism: "the picture could not express the whole tragedy of this murderous paragraph."

Self-confident and happy, these two students display their love in a workshop in the Bauhaus building
in the spring of 1928. They are even "engaged," as the title of Edmund Collein's photograph reveals.

The Man in Love by Paul Klee, created in 1923, has only one thing in mind: the woman of his desire.

Workshop of Emotions

The Bauhaus community was a big family. They shared their lives with each other—and sometimes their love, too. At the same time, they were quite diverse; they loved freely and without restraint, but also quite often ended up at the altar in true bourgeois fashion.

Love as a Testing Ground

In parallel with the lively discussions on the future man, many of the students were already very modern in matters of love. Not only did they bathe together unclothed without embarrassment, but often shared beds, without the need for a marriage certificate. They were always on the lookout for new, contemporary forms of togetherness. Some students were doubtful that marriage was still appropriate and could work, and the failed or unhappy marriages of their masters seemed to confirm their suspicions. In 1920 Gunta Stölzl

> **"I love the love without an object, the high, eternal intensity."**
>
> **Walter Gropius, 1919**

"An enlightened heart through the right faith": in 1921 Johannes Itten designed this saying by O. Z. Ha'nish, the founder of the Mazdaznan movement.

wrote in her diary: "Gropius wants a divorce, Feininger is in agony, Itten is dominated by a vampire, Frau Brandenburg and Lindig have broken up, and she is expecting a child by Heller. Brenner's marriage was on the point of collapse. Only the Marcks' marriage is harmonious and radiant."

Sometimes children were the result of such "free" encounters, and these too formed the inspiration for workshop pieces such as wonderful cradles. And because life at the Bauhaus would be nothing without celebrations, the birth of a child—whether or not the parents were married—was celebrated exuberantly. Of course, the moralistic eyes of the Weimar citizens were particularly focused on every Bauhaus child born outside marriage. They observed with horror, for example, how a new cradle for such a child "was driven in a kind of triumphal procession to the involuntary parents' home," and expressed their malicious disgust in the *Weimarer Zeitung*, once again stirring up strong feeling against the Bauhaus.

The freedom-loving atmosphere at the Bauhaus was certainly bound to encourage unconventional styles of living and loving. Thus there were a few acknowledged homosexual partnerships. In 1920, a young man calling himself Hans Voelcker filled in the Bauhaus application form; he was born Johanna Voelcker, and claimed to be permitted by the authorities to wear male clothes.

"Fleshly Delight breeds fleshly lust!"

For a short time the sex-life of the *Bauhäusler* was seen in a rather murky light at the Bauhaus itself. Johannes Itten's Mazdaznan teachings were aimed at "higher," purely spiritual exchanges of energy, and this specifically through eating the right foods. Oskar Schlemmer composed a splendidly teasing rhymed commentary: "food enters the stomach, and there it begins its journey. by means of some bodily heat it passes through the intestines. but its noble juices are converted into spiritual forces such as intellect and love, while you must break off from all the lower urges (fleshly delight breeds fleshly lust!)"

Georg Muche and his wife, naked and relaxed, in front of the Haus am Horn in an etching by Farkas Molnár, 1923.

"Naked art"

The naked human being is also the free, modern human being, who has cast off the ballast of the past and is open to the new. In 1923, Farkas Molnár depicted a young naked couple. Next to the naked bodies he placed the Bauhaus "naked" Weimar model house, which was also reduced to its essential shape, without any frills or ornamentation. Students gripped by photographic fever at the Dessau Bauhaus also discovered the naked and unadorned body, portraying it with a gentle eroticism. In addition, unclothed men and women could be seen at the Bauhaus' life drawing classes. With encouragement from Schlemmer, what might sound academic to many was handled here in a most unacademic manner. There were no hired profes-

sional nude models: the Bauhaus students simply took their clothes off. Accompanied by music, and with the lighting expressing varying moods, they drew each other, as though it were the most natural thing in the world.

The Bauhaus as Marriage Bureau

At the Bauhaus, free love meant that everyone was free to live and love in his or her own fashion. There were no hard and fast aims or values, and so some were quite traditional in their approach to love. They would get to know each other, fall in love and get married. Above all in the Dessau period, many weddings took place, and not only among the student community: Gerhard Marcks, Georg Muche, Walter Peterhans, and Mart Stam were just a few of the masters who married students. Nor were the junior masters (*Jungmeister*) immune to such relationships. Fräulein Anni Fleischmann from the weaving workshop, for example, soon became Anni Albers, and in 1929 Gunta Stölzl, the only female *Jungmeister*, finally married Arieh Sharon, who worked in the building department. Of course there were also cases of unrequited love in droves, above

all among students who had become infatuated with a master. For a long time Marianne Brandt, one of the most creative members of the metal workshop, was hopelessly in love with her master, László Moholy-Nagy, who consequently took hardly any notice of her. It was Moholy's wife Lucia who complained about his behavior to the young woman. Moholy-Nagy replied calmly: "Anyone who loves me must work for me."

Love Among the Directors

With the founding of the Bauhaus, one of the most eccentric and fascinating women of the time came to Weimar. This was Alma Mahler, who exercised a special attraction over famous artists, and who could clearly live only in the proximity of such men. At the time of the foundation of the Bauhaus she was living with the writer Franz Werfel, despite being married to Walter Gropius. Her ideal arrangement would have been to live for half the year with Werfel and the other half with Gropius, with whom she had a daughter, Manon, called Mutzi. She saw nothing strange about this proposal. But this was too much for Gropius,

who still loved Alma but who increasingly suffered from her domineering and capricious behavior, and he considered divorce. He had in any case for some time been finding warmth and understanding from other women. In fact, in 1923 he married the young Ise Frank, who saw it as her task to place herself entirely at the service of the Bauhaus, although she had no official position there. This she did with total devotion, so that she was sometimes addressed as Frau Bauhaus. She raised funds and recruited members for the Circle of Friends of the Bauhaus, organized the kitchen layout for the canteen at Dessau, and contributed significantly to the interior decoration of the masters' houses. At the same time, during those years the marriage was continually haunted by the ghost of Almachi, as Gropius called Alma Mahler, to whom Ise at first felt inferior. A year after the wedding, Gropius wrote to his Ise: "I have a feeling that you have already reached the point where you have become a partner of equal rank in everything that concerns both of us, who has the right to advise me in all things ... I admit that my activities, like those of the Bauhaus, are a good setting for human and

intellectual development ..." In 1925 the couple experienced a heartrending disaster: their child died in the womb during an appendix operation on Ise. She never became pregnant again. A few years later Gropius also lost his beloved Mutzi, who had been living with Alma, to poliomyelitis.

The second director of the Bauhaus, the Swiss Communist Hannes Meyer, loved women. Since joining the Bauhaus he felt—despite an initial sense of discomfort—"younger than ever, younger than I felt at seventeen as a gauche student." In 1928, asked about his greatest disappointment at the Bauhaus in the *bauhaus* magazine, he replied with great candor: "mostly in matters of love, because I shouldn't or can't or am not allowed to participate." However, he was reputed to have conducted several relationships with female students. He lived quite openly in a relationship with Lotte Beese, which resulted in a little son, Peter. But only a short time after this, the former Bauhaus director married the Bauhaus student Lena Bergner. Both women came from the weaving workshop, the one

whose carpets Meyer mocked at the beginning of his directorship as "the emotional complexes of young girls." Some time after his appointment as director of the Bauhaus, Ludwig Mies van der Rohe summoned the interior architect Lilly Reich to the Bauhaus. Reich was conspicuous for her great ability. She was the first woman to join the board of directors of the Werkbund, the German Work Federation, and took part in all Mies' important projects, such as the decoration of the Barcelona Pavilion. She was Mies' partner, not only professionally but also privately, although he was still married. Reich, who was used to making decisions, even chose the clothes worn by Mies' children. Soon they began to look like old ladies. She even determined the amount of his monthly payments to Ada. As director of the newly organized extension workshop, she operated in her usual energetic manner. But so much determination on the part of a woman was not always welcomed at the Bauhaus. Reich was perhaps the first woman at the Bauhaus to hold fast against a cold wind from the male world without withering—and indeed to give as good as she got.

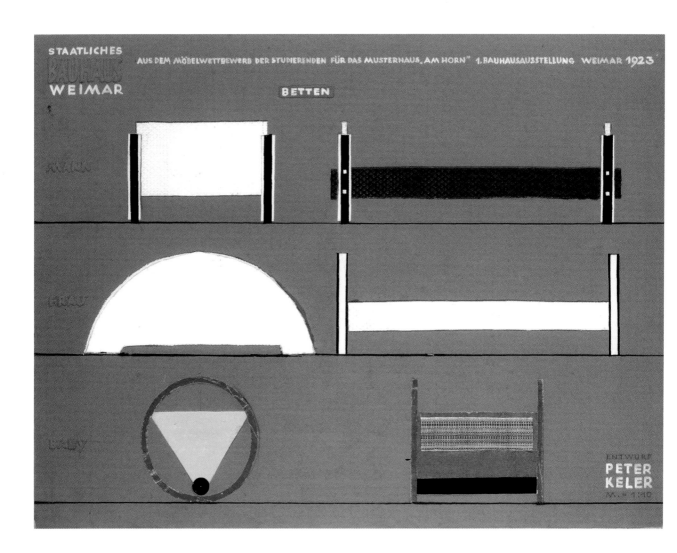

In 1922 Gropius had organized a furniture competition for the Haus am Horn. Peter Keler designed a bed for a man, a bed for a woman, and a cradle for the baby. The starting point for his designs was the discussion at the Bauhaus about basic forms and the primary colors that corresponded to them. Kehler allocated the color blue to the circle, red to the square, and yellow to the triangle.

Lena Meyer-Bergner and Hannes Meyer on the beach, 1931. After his dismissal in 1930 as Bauhaus director, the Marxist Hannes Meyer worked for many years in the USSR as an urban planner. Some leftist Bauhaus members who were no longer able to study at the Bauhaus followed him. In 1931 Meyer married the former Bauhaus member Lena Bergner from the weaving workshop.

Today

"... it is not the products of the Bauhaus that are the decisive thing, but the direction in which we drove forward a method that can be employed today with the same vitality as thirty years ago."

Walter Gropius, 1959

The Bauhaus After 1933

After the Bauhaus dissolved itself in July 1933, some of its members left Germany and emigrated—in some cases to continue working in the spirit of the Bauhaus. Others continued to work successfully in Germany, while some, such as Schlemmer, were disbarred from working and their art considered "degenerate." Many Jewish Bauhaus members, such as Otti Berger and Friedl Dicker, were pursued by the Nazis and murdered.

The "New Bauhaus in Chicago"

At Gropius' instigation, in 1937 László Moholy-Nagy took over the direction of a design school in Chicago, to which he gave the name the New Bauhaus. In his inaugural speech he said: "This is not so much a school as a laboratory, where it is not the results that count, but the ways in which the results are attained." Later he renamed it the School of Design, and in 1984 the Institute of Design. The school started out from the Bauhaus' program of education, but then struck out its own path.

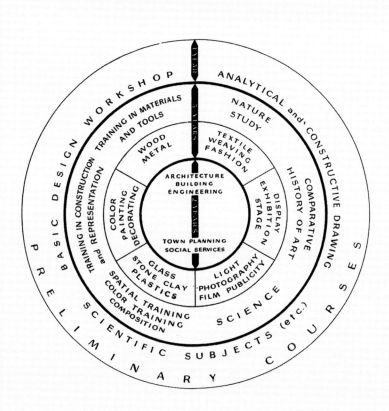

Curriculum of the New Bauhaus in Chicago, c. 1938 (see page 40)

Bauhaus Members at Black Mountain College

In 1933 Albers became a professor at Black Mountain College, North Carolina, which became an important rallying point for the American avant-garde. Here he continued to develop the preliminary course which he had led at the Bauhaus, and in which the young Robert Rauschenberg also enrolled in 1949. Apart from Josef Albers, his wife Anni taught weaving and textile art, the graphic designer, painter and stage-set designer Xanti Schawinsky continued the Spectodrama experimental stage work that he had begun at the Bauhaus, and the former Bauhaus member Stefan Wolpe became director of the music department. Lyonel Feininger and Gropius too taught in the context of the summer courses at Black Mountain College.

The Bauhaus Building under National Socialism

In 1933 a provincial working women's college moved into the Dessau Bauhaus. The assembly hall was painted in National Socialist colors and a portrait of Hitler was hung up in the stairwell. In 1940 the Junkers factory took over almost the whole building. A building team of Albert Speers used some rooms as offices. In 1945 the building was hit by an incendiary bomb. The interior was partly destroyed, and the façade almost entirely so.

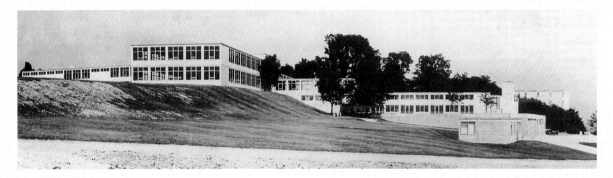

The College of Design Ulm, 1955.

"The goal of the Bauhaus is not a style, not a system, dogma, or canon, not a recipe and not fashion!"

Walter Gropius, 1930

The College of Design in Ulm

On the initiative of Otl Aicher and Inge Scholl, a sister of the resistance fighters Sophie and Hans Scholl, the College of Design in Ulm was founded in 1953, seeing itself initially as the continuation of the Bauhaus. Gropius even offered the founders the right to call the college the Bauhaus Ulm. The majority of the board of teachers however declined, in order to stress the independence of the new institution. Its first director was the former Bauhaus member Max Bill, who participated significantly in the concept of the college. Josef Albers, Walter Peterhans, and Johannes Itten taught at the college, which closed in 1968.

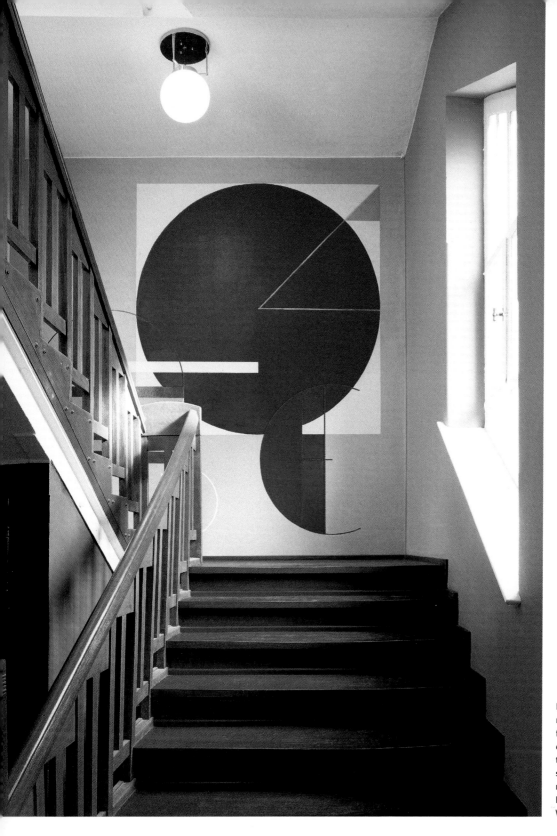

Herbert Bayer's murals, designed for the 1923 Bauhaus exhibition, seen after their restoration in a staircase of the current main building of the Bauhaus–Universität Weimar.

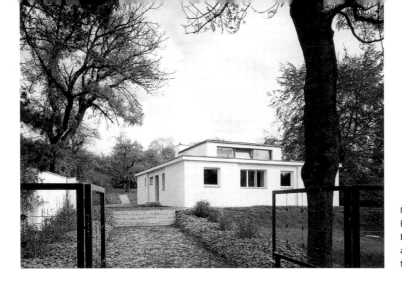

Georg Muche built the Haus am Horn in Weimar for the major Bauhaus exhibition of 1923. After a long restoration, it is now open to the public again.

The Bauhaus Myth

The Bauhaus still breathes life into design, architecture, and art. It is invoked as an inspiration for fashion collections, hairdressing trends, or perfume bottles. The steel tube furniture or the Wagenfeld lamp have long since entered our living rooms, if only in the soulless versions from discount furniture stores. But what do the historic Bauhaus sites look like today, and what is happening there?

Weimar

In Weimar, no one complains about the Bauhaus any more. On the contrary: the people of Weimar love the Bauhaus so much that they are going to build a special museum devoted to it, to be opened in 2018. Until then, the compact but exciting permanent exhibition can be visited in the small Kulissenhaus on the Theaterplatz. Many of the exhibits to be seen here were donated by Walter Gropius as early as 1925 to the State Art Collections in Weimar (Staatlichen Kunstsamm-

> "But a 'Bauhaus style' would be a reversion to academic stagnation, to that life-threatening state of lethargy which the Bauhaus was once created to combat. May the Bauhaus be preserved from such a death."
>
> **Walter Gropius, 1934**

117

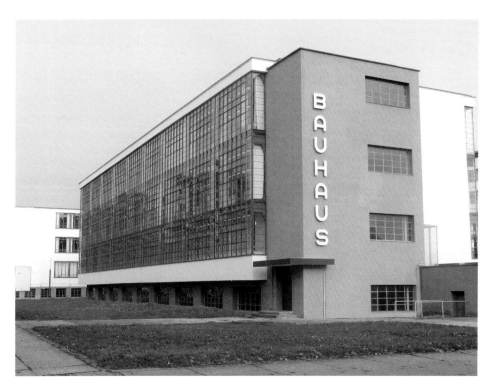

View of the workshop wings of the Bauhaus Dessau today.

lungen Weimar). Did the museum people at the time realize what a treasure they had in their hands? And there is much more to be seen in Weimar in relation to the Bauhaus. Its school buildings, designed by Henry van de Velde, are still standing. Today they are not museum premises, but are used by the Bauhaus University. Anyone who is curious can search for traces of the Bauhaus period here—and there is much to be discovered. High above the park on the Ilm, the restored Haus am Horn, built as a model house for the Bauhaus, is again open to visitors. It really is still possible to sense how strange and fascinating this white cube must have appeared to the first visitors in 1923. Like the other Bauhaus sites in Weimar and Dessau, in 1996 it was raised to the rank of a UNESCO World Cultural Heritage site.

Dessau

A visit to Dessau today is richly rewarding. The costly restoration work was completed in 2006. New and exciting insights into the historic color styling have influenced the work, which can produce the breathtak-

ing sensation of having traveled back in time to the year 1926. Not long ago, some of the original windows, long believed to have been destroyed, were returned to the places where they were first installed. They have had a strange journey; in the course of the first great refurbishments of 1976 they were dismantled, to be replaced by new ones. They were taken home by enterprising Dessauers, who used them to build stylish little conservatories. Many years later, the treasures were discovered, repaired and restored, and put back in place in the Bauhaus building. The main function of this "icon of Modernism" today is as the seat of the Bauhaus Dessau Foundation (Stiftung Bauhaus Dessau), set up in 1994. No longer is it an educational center in the sense of the historic Bauhaus. Nevertheless, exciting things are happening here. On the one hand, the foundation has the task of researching, preserving, and communicating the Bauhaus heritage, and on the other, of tackling the living environment of today, for some time now with the theme of the "city." On the occasion of the Bauhaus centenary in 2019 a

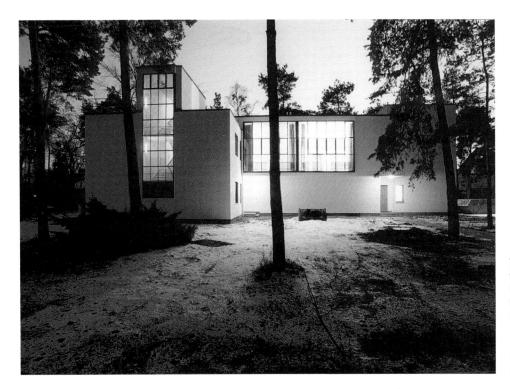

The Kandinsky/Klee house today. The Kandinsky family lived on the left 1926–1932, the Klee family on the right 1926-1933.

View of the masters' houses ensemble today.

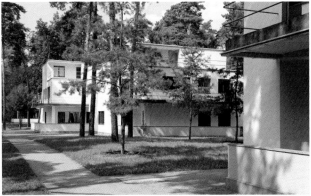

newly built Bauhaus museum by the Spanish architectural firm Gonzalez Hinz Zabala is to be opened in the city centre of Dessau, which will present the important collection of the Bauhaus Dessau Foundation.

Only a few minutes' walk away from the Bauhaus building are the masters' houses, superbly restored in recent years; here one can tread in the footsteps of the famous masters. The checkered history of these houses, with their repeated structural alterations and war damage, is hardly noticeable today. Here the visitor can, for example, see Wassily Kandinsky's living-room alcove, once again gleaming with gold, and feel overwhelmed. Thanks to the excellent reconstruction of the colors of these Modernist artists' houses, anyone who wishes can pursue the secret of Georg Muche's black-painted bedroom; Muche himself was so terrified by its effect that he spent only one night in it. For a long time the absence of Gropius' detached house, as well as László Moholy-Nagy's half of a double house, the other half of which was occupied by Feininger, formed a painful gap. Both houses were destroyed by a bomb attack in the Second

World War. In 1956, a residential house was built on the existing foundations of the Gropius house, entirely traditional, with a pointed roof. At the turn of the millennium a lengthy, fiercely blazing discussion flared up over the right way to deal with this location. In the end a decision was made in favour of the designs of the Berlin architectural office of Bruno-Fioretti-Marquez, and of an urbanistic renovation which would not be a 1:1 reconstruction, but a `blurred memory' by means of a con-

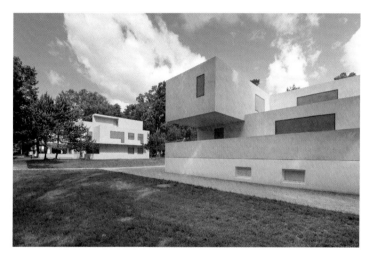

The 'new masters' houses' in Dessau. In front, the Gropius house, behind it the Moholy-Nagy house.

temporary architectural language. These `new masters' houses' were opened in 2014.

Berlin

The old telephone factory in the Steglitz district of Berlin, which served as a new school building after the closure of the Bauhaus building in Dessau, was demolished in the 1970s. Only a few years later the Bauhaus Archive, founded in 1960, moved into a new building in the western center of Berlin, which Gropius had designed especially for the institution. This building, with its unusually shaped roof, was originally designed for a different location, namely Darmstadt, where the archive had been founded by the art historian Hans Maria Wingler. But the design could not be executed there. It was, once again, Gropius who laid the foundation for this unique archive, whose sub-title is "Museum of Design," by donating his extensive private collection. With its documents and objects, it has now grown to become the largest Bauhaus collection in the world. This has resulted

in an acute shortage of space, so an extension building by the architect Volker Staab is planned and will be opened in 2019, where in future the exhibitions of the Museum für Gestaltung will be presented. Gropius' existing building will then house only the archives.

The permanent collection of the Bauhaus Archive exhibits treasures from the collection of the whole history of the Bauhaus. In addition, the special exhibitions mounted here focus not only on specific aspects of the historic Bauhaus, but also on themes of contemporary design, architecture and photography.

In addition to all this, the Bauhaus Archive is a place for research, open to all interested parties. Here a female

View into the exhibition hall of the
Bauhaus Archiv.

student who has come especially from Japan sits next to an English professor researching documents in the archive. At the same time, a school class visits the extensive library, amazed to find whole shelves filled with books about the Bauhaus. Without this unique archive and its staff, many of these books, research projects, or exhibitions on the Bauhaus could never have been realized—and the world would be correspondingly poorer in knowledge about the history, personalities and achievements of the Bauhaus.

Because of the enforced closure of the Bauhaus Dessau in 1932, the inhabitants of the masters' houses left the city. In 1998/99 the Kandinsky/Klee house was refurbished and restored. Today the first floor of the staircase shines in its original colors, waiting for fascinated visitors to arrive.

A place that houses unbelievable treasures: the building designed by Walter Gropius and opened in 1979 for the Bauhaus Archive in Berlin. In 1997 the building, with its characteristic saddle-shaped shed roofs, was listed as a historic building. In the foreground stands one of two columns by the former Bauhaus member Max Bill, designed for the twenty-fifth anniversary of the archive, which was founded in 1960.

Picture List

Cover:

Front cover: View onto the wing of the Bauhaus building by Walter Gropius, 2008. Photographer: Horst Wedemeyer. Archive Prestel Verlag.

Back cover: The Bauhaus Band (detail), 1931. Photographer: unknown. Bauhaus Archiv Berlin.

Outside front flap: Walter Funkat, *Glaskugeln, Metallisches Fest (Glass Spheres, Metal Festival)* 1929. Galerie Kicken Berlin.

Inside front flap: left to right: Cover of the Bauhaus Volume 6, designed by Theo van Doesburg, Ketterer Kunst (www.ketter-erkunst.de); Photograph taken of the Bauhaus building at night, c. 1926. Photographer: unknown. Bauhaus Archiv Berlin; Aerial view of the Bundesschule des Allgemeinen Deutschen Gewerkschaftsbundes (State School of the German Confederation of Trade Various) by Hannes Meyer with Hans Wittwer, 1930, Photographer: credited to Junkers, Dessau. Baudenkmal Bundesschule Bernau e. V.; Bauhaus wall painting b 24 taken from the Tapetenbuch, 1932, Archive of the Tapetenfabrik Rasch; Bauhaus Archiv Berlin.

Outside back flap: The reconstruction of Walter Gropius' Director's room at the Bauhaus University in Weimar under the direction of Gerhard Oschmann in 1999. Original design from Walter Gropius in 1923 with a tapestry by Else Mögelin, a rug by Benita Otte, furniture and a ceiling lamp by Walter Gropius along with a desk lamp by Wihelm Wagenfeld. Photographer: Hans Engels. Archive Prestel Verlag.

Inside back flap: Group photograph of the Bauhaus masters, 1926. Photographer: unknown. Bauhaus Archiv Berlin.

Title Page: Students from the weaving studio, 1927. Photographer: T.Lux Feininger (?). Bauhaus Dessau Foundation.

Page 5: Gropius as a soldier riding a horse, c. 1917. Photographer: unknown. Bauhaus Archiv Berlin.

Page 6: Monument in honor of the murdered workers during the Kapp Putsch at the cemetery in Weimar by Walter Gropius, c. 1922. Photographer: unknown. Bauhaus Archiv Berlin.

Page 7: William Morris, *Empty*, 1896.

Page 8: Die Großherzoglich Sächsische Kunstgewerbeschule (Grand Ducal Saxon Arts and Crafts School) in Weimar by Henry van de Velde, c. 1904–1911. Photographer: Louis Held. Bauhaus Archiv Berlin.

Page 9: Portrait of Henry van de Velde. Photographer: Louis Held. Bauhaus Archiv Berlin.

Page 10: Portrait of Walter Gropius, in Janikow, 1910. Photographer: unknown. Bauhaus Archiv Berlin.

Page 11: Office building at the Werkbund exhibition in Cologne by Walter Gropius with Adolf Meyer, 1924. Photographer: unknown. Bauhaus Archiv Berlin.

Page 12: Max Pechstein (?), Flyer of the *Arbeitsrates für Kunst* in Berlin (Workers Council for Art), 1919, Woodcut. Photographer: Atelier Schneider. Bauhaus Archiv Berlin.

Page 13: Die Großherzoglich Sächsische Kunstgewerbeschule (Grand Ducal Saxon Fine Arts College) in Weimar, 1904–1911. Photographer: unknown. Bauhaus Archiv Berlin.

Page 14: Main building of the Fagus Factory by Walter Gropius with Adolf Meyer, c. 1911, Fagus-GreCon, Alfeld.

Page 15: Machine hall and Deutz pavilion for the Werkbund exhibition by Walter Gropius and Adolf Meyer, Cologne 1914. Photographer: unknown. Bauhaus Archiv Berlin.

Page 17: Marcel Breuer, nesting tables "b9 a-d". thonet, current product (www.thonet.de).

Page 18: Portrait of Otti Berger, c. 1927. Photographer: Lucia Moholy. Bauhaus Archiv Berlin.

Page 19: Portrait of Vera Meyer-Waldeck in negative, 1930. Photographer: Gertrud Arndt. Bauhaus Archiv Berlin.

Page 20: Thomas Theodor Heine, *Der Kampf gegen das Ornament* (The Struggle against the Ornamentation), 1928. Published in the preiodical *Simplicissimus* on 3 September 1928.

Page 21: Marianne Brandt, Hin Bredendieck, nightstand lamp from the Kandem company, 1929. Bauhaus Archiv Berlin.

Page 22: Wilhelm Wagenfeld, table lamp, 1923–24. Bauhaus Archiv Berlin.

Page 23: Nightstand lamp (mushroomlamp) from an unknown designer. From the catalog of Bünke and Remmler, c. 1930. Bauhaus Archiv Berlin.

Page 24: Poster *bauhaus dessau im gewerbemuseum basel* (bauhaus dessau in the museum of trade basel), 1929, litho-graphy black and red on yellow paper, 127 x 90 cm. Bauhaus Archiv Berlin.

Page 25: Bauhaus exhibition in Moscow, 1931. Photographer: unknown. Galerie Kicken Berlin.

Page 26: Cover of Bauhaus Volume 8, 1925, second edition. Design: László Moholy-Nagy. Bauhaus Archiv Berlin.

Page 27: Bauhaus wall paper, 1930. Taken from the *Tapetenbuch 1930*. Archive of the Tapetenwerke Rasch.

Page 29: Georg Adams, formerly Teltscher, postcard for the Bauhaus exhibition and for the Bauhaus week 1923 in Weimar, 1923, color lithograph on cardboard, 11.0 x 9.4 cm. Quittenbaum (www.quittenbaum.com).

Page 30: Ludwig Mies van der Rohe with Amédée Ozenfant at the Bauhaus in Dessau, 1931. Photographer: Josef Albers. Reproduction: Uwe Jacobshagen. Bauhaus Dessau Foundation.

Page 31: Gret Palucca, Nina and Wassily Kandinsky together with an unknown person on the roof of a master house, Dessau, 1928. Photographer: unknown. Fonds Kandinsky, Bibliothèque Kandinsky, Centre Pompidou.

Page 32: Lyonel Feininger, *Cathedral,* title page of the Bauhaus manifesto, 1919, woodcut, 31.9 x 19.6 cm; Bauhaus Archiv Berlin.

Page 33: Portrait of Walter Gropius, 1920. Photographer: E. Lill. Bauhaus Archiv Berlin.

Page 34 left: Oskar Schlemmer: Bauhaus Signet, 1922.

Page 34 right: Karl Peter Röhl, Signet of the State Bauhaus Weimar, 1919. Bauhaus Archiv Berlin.

Page 35: View into the metal studio in Weimar, c. 1922. Photographer: unknown. Bauhaus Archiv Berlin.

Page 36: Portrait of Johannes Itten, 1920. Photographer: Paula Stockmar. Bauhaus Archiv Berlin.

Page 37: Material and contrast study in wood, glass, and feathers by Margit Téry-Adler, 1920. Photographer: unknown. Bauhaus Archiv Berlin.

Page 38: Franz Singer, A *Color Penetration of Yellow and Violet*, from Paul Klee's color class, 1922–23, four sheets mount-

ed on cardboard, watercolor, and graphite on paper, 63 x 49.7 cm. Bauhaus Archiv Berlin.

Page 39:Marianne Brandt, small tea infuser, 1924, tombac (copper and zinc) and ebony, 7.5 cm. Kunsthaus Lempertz (www.lempertz.de).

Page 40: Walter Gropius (draft), Class Schedule at the Bauhaus, 1922. Bauhaus Archiv Berlin.

Page 41: The Sommerfeld house by Walter Gropius with Adolf Meyer, 1920–21. Photographer: Carl Rogge, Bauhaus Archiv Berlin.

Page 42 right: Portrait of Theo van Doesburg, 1924. Photographer: Lucia Moholy. Bauhaus Archiv Berlin.

Page 42 left: Cover of Bauhaus Volume 6, designed by Theo van Doesburg, 1924. Ketterer Kunst (www.kettererkunst.de).

Page 43: Lothar Schreyer, *Figurine for 'Moon Play'*, 1923, color lithograph, 39.8 x 29.8 cm. Bauhaus Archiv Berlin.

Page 44: László Moholy-Nagy, *Self-portrait, c.* 1926, photogram and collage, 30.2 x 23.6 cm. Bauhaus Archiv Berlin.

Page 45: Walter Gropius, series houses and building components as a model / "building blocks on a large scale", "goal for the living space construction", 1923. Bauhaus Archiv Berlin.

Page 46: Anni Albers, wall hanging, three-ply upholstery material in black, orange, and white, 1926, cotton and chemical yarns, 175 x 118 cm. Bauhaus Archiv Berlin.

Page 47: Postcard with an image of the Bauhaus building. Photographer: unknown. Written by an unknown member of the Bauhaus, 1927, Bauhaus Archiv Berlin.

Page 48/49: The Dessau-Törten settlement by Walter Gropius, *c.* 1929. City of Dessau-Roßlau, city archives.

Page 50: Walter Determann, design for a Bauhaus settlement, main building (two perspectives), *c.* 1921, colored pencil, watercolor, ink, and graphite on transparent paper, 62.70 cm x 79.50 cm. The Foundation of Weimar Classics.

Page 51: Wassily Kandinsky, *Small Worlds V*, color lithograph, 1922, 27.4 x 22.4 cm. Städtische Galerie im Lenbachhaus, Munich.

Page 52: Questionnaire drawn up by Wassily Kandinsky for his class in wall painting. Completed by an unknown Bauhaus member, 1923, lithograph, pencil, and color pencil on paper, 23.3 x 15.1 cm. Bauhaus Archiv Berlin.

Page 53: Gunta Stölzl, rug runner (detail), 1923, Smyrna knots made from various materials including hemp and wool, 505.0 x 100 cm. Bauhaus Archiv Berlin.

Page 54: Coffee pot and cup by Otto Lindig, three cups by Marguerite Friedlaender, combination teapot by Theodor Bogler. Photographer: Lucia Moholy, 1923, Bauhaus Archiv Berlin.

Page 55: Kurt Schmidt, *Man at the Control Panel*, stage set, 1924, tempera, ink, and silver aluminum, 34.0 x 50.5 cm. Bauhaus Archiv Berlin.

Page 56: Night image of the Bauhaus building, *c.* 1926, Photographer: unknown. Bauhaus Archiv Berlin.

Page 57: Aerial image of the Bauhaus building Dessau, 1926, by Walter Gropius. Photographer: Junkers Luftbild. Fonds Kandinsky, Bibliothèque Kandinsky, Centre Pompidou.

Page 58 left: The maters' houses in Dessau by Walter Gropius, 1926. Photographer: Lucia Moholy. Bauhaus Archiv Berlin.

Page 58 right: Lyonel and Julia Feininger in the studio at

Feininger's master house, Dessau, 1927. Photographer: unknown. Bauhaus Archiv Berlin.

Page 59: Hinnerk Scheper and students of the wall-painting workshop, *c.* 1926, Photographer: unknown. Bauhaus Archiv Berlin.

Page 60: Josef Albers, tea glass, 1926, porcelain, glass, chrome, nickel, steel, and ebony. Bauhaus Archiv Berlin.

Page 61: Herbert Bayer, *design for a new typeface*, image taken from *Offset Buch und Werbekunst (offset book and commercial art)*, Nr.7, 1926. Bauhaus Archiv Berlin.

Page 62: Gropius' Building Studio, *c.* 1927. Photographer: Edmund Collein. Galerie Kicken Berlin.

Page 63: Hannes Meyer (detail) 1928. Photographer: unknown. Bauhaus Archiv Berlin.

Page 64: Hin Bredendieck, Hermann Gautel, demonstration board for the work stool "me 1002," 1930. Bauhaus Archiv Berlin.

Page 65: *Laubenganghäuser* (Housing with Balcony Access) by Hannes Meyer and the building department of the Bauhaus, view of the northern side, 1930. Photographer: unknown. Reproduction: Horst Fechner. Bauhaus Dessau Foundation.

Page 66: Aerial view of the Bundesschule des Allgemeinen Deutschen Gewerkschaftsbundes (State School of the German Confederation of Trade Various) by Hannes Meyer with Hans Wittwer, 1930. Photographer: credited to Junkers, Dessau. Baudenkmal Bundesschule Bernau e. V.

Page 67: Eduard Ludwig, *Group of Houses on the River Havel*, 1932, pencil and tempera on cardboard. Bauhaus Archiv Berlin.

Page 68: Rudolf Ortner, one-family house taken from the architecture class conducted by Mies van der Rohe, 1932. Archive Rudolf Ortner, private collection M. Ortner-Bach.

Page 69: Hajo Rose, *Montage Self-portrait (with the Bauhaus façade)*, 1930. Galerie Kicken Berlin.

Page 70: Paper folds by Alphons Frieling taken from the preliminary course conducted by Josef Albers, 1929. Photographer: unknown. Bauhaus Archiv Berlin.

Page 71: Tactile panels made from thread by Otti Berger taken from the preliminary course conducted by László Moholy-Nagy, *c.* 1927, various textile threads fixed on wire netting, therein loosely integrated, multi-colored square paper cards, 14.0 x 57.0 cm. Bauhaus Archiv Berlin.

Page 72: Kalman Lengyel, flyer for "standard furniture," with images of pieces by Kalman Lengyel and Marcel Breuer, 1928. Bauhaus Archiv Berlin.

Page 73: Oskar Schlemmer, *Metalltanz (Metal Dance)* (Karla Grosch), Bauhaus stage in Dessau, 1929. Photographer: Robert Binnemann, Bauhaus Archiv Berlin.

Page 74: Joost Schmidt, *Nine Squares, Variations with "P"*, *c.* 1929, colored ink, partly sprayed, watercolor over lead, collage, newspaper collage on cardboard, 42.1 x 43.1 cm. Bauhaus Archiv Berlin.

Page 75: Walter Peterhans (?), untitled. Still life with fabric, fish and thread, *c.* 1929. Photographer (reproduction): Uwe Jacobshagen. Bauhaus Dessau Foundation.

Page 76: Joost Schmidt, *The Seven Chakras*, taken from: Nature—Human Worth. The Sense as Directional Tools. Studies on the Topic of "Man and Space," elements from a design

course, preparatory teaching notes, *c.* 1930. Photographer (reproduction): Kelly Kellerhoff. Bauhaus Dessau Foundation.

Page 77: Photo essay on the Bauhaus in Berlin in *Weltspiegel, Berliner Tageblatt* 1932. Bauhaus Archiv Berlin.

Page 79: Students of the weaving workshop in the Bauhaus building, 1928. Photographer: Lotte Beese. Bauhaus Archiv Berlin.

Page 80: Lyonel Feininger on his bicycle in Dessau, 1928. Photographer: Andreas Feininger. Houghton Library, Harvard University, Cambridge, Mass.

Page 81: Paul Klee in front of his master house, 1928. Photographer: Karla Grosch. City of Zurich, Stadtarchiv, VII.228. E. Attenhofer, M. W. Lenz, estate.

Page 82: Sport at the Bauhaus, *c.* 1927. Photographer: T. Lux Feininger. Bauhaus Archiv Berlin.

Page 83: Bathing trip on the Elbe, *c.* 1928. Photographer: Edmund Collein. Galerie Kicken Berlin.

Page 84: Ludwig Hirschfeld-Mack, card for the kite festival, 1921–22, lithograph, 15.6 x 8.5 cm. Bauhaus Archiv Berlin.

Page 85: Paul Citroen, *Masdasnan teachings*, *c.* 1922, ink and watercolor on transparent paper, 24.5 x 30.5 cm. Bauhaus Archiv Berlin.

Page 86: Lyonel Feininger, postcard for the Bauhaus festival of lanterns, 1922, lithograph on yellowed cardboard, 9.0 x 13.9 cm (print). Bauhaus Archiv Berlin.

Page 87: Teachers, students, and guests at the Bauhaus in Weimar, *c.* 1923. Photographer: unknown. Bauhaus Archiv Berlin.

Page 88: Party for the naturalization of Wassily and Nina Kandinsky, 1928. Photographer: unknown. Fonds Kandinsky, Bibliothèque Kandinsky, Centre Pompidou.

Page 89 left: Lis Beyer with a costume design, *c.* 1928. Photographer: unknown. Galerie Kicken Berlin.

Page 89 right: Heinrich Koch dressed as a checkered visitor at the "White Festival." Photographer: unknown. Bauhaus Archiv Berlin.

Page 90: kostufra (communist student group), title page of the brochure *bauhaus mouthpiece of the students*, April 1932. Bauhaus Archiv Berlin.

Page 91: Students on a balcony of the studios, taken from the series "Bauhausköpfe," *c.* 1931. Photographer: Fritz Schreiber. Galerie Kicken Berlin.

Page 92: The Bauhaus Band (detail), 1931. Photographer: unknown. Bauhaus Archiv Berlin.

Page 93: Mies van der Rohe's last outing with his students, 1933. Photographer: unknown. Bauhaus Archiv Berlin.

Page 94: Bauhaus party at the restaurant Ilmschlößchen, 1924. Photographer: Louis Held. Bauhaus Archiv Berlin.

Page 95: "White Festival", 1925. Photographer: unknown. Bauhaus Archiv Berlin.

Page 96: Herbert Bayer, *the mouth*, 1926, collage, mixed materials, newspaper clippings pasted on cardboard, 59.0 x 125.5 cm. Bauhaus Archiv Berlin.

Page 97: "Nonsense Soldier". 1929. Photographer: Willy Römer. Agentur für Bilder zur Zeitgeschichte, Berlin.

Page 98: Oskar Schlemmer, *Bauhaustreppe (Bauhaus Stairway)*, 1932, oil on canvas, 162,3 x 114,3 cm, Museum of Modern Art, New York.

Page 99: Bauhaus members on the terrace in front of the cafeteria, *c.* 1929. Photographer: unknown. Bauhaus Archiv Berlin.

Page 101: Albert Mentzel and Lotte Rothschild, *c.* 1930. Photographer: Etel Mittag-Fodor. Bauhaus Archiv Berlin.

Page 102: Group of Bauhaus members (Georg Hartmann, Naf Rubinstein, Miriam Manuckiam, Günter Menzel), *c.* 1929. Photographer: T. Lux Feininger. Bauhaus Archiv Berlin.

Page 103: Marcel Breuer and his "harem," 1927. Photographer: Erich Consemüller, private collection, Bremen.

Page 104: *Engaged*, 1928. Photographer: Edmund Collein. Galerie Kicken Berlin.

Page 105: Paul Klee, *The Man in Love*, 1923, 91, lithograph, 27.4 x 19.0 cm. Zentrum Paul Klee. Bauhaus Archiv Berlin.

Page 106: Johannes Itten, "An enlightened heart through the right faith", 1921, color lithograph, 34.7 x 24.7 cm. Ketterer Kunst (www.kettererkunst.de).

Page 107: Farkas Molnár, *Georg and El Muche with the Haus am Horn*, 1923, dry point, plate 28.8 x 19.7 cm, sheet 41.7 x 32.4 cm. Bauhaus Archiv Berlin.

Page 108: Walter Gropius with Manon and Alma Mahler, *c.* 1917. Photographer: unknown. Bauhaus Archiv Berlin.

Page 109: Figure drawing in the Bauhaus building in Dessau, 1930. Photographer: unknown. Bauhaus Archiv Berlin.

Page 110: Peter Keler, Sketch for a Cradle, 1924, gouache on paper, collage, sheet 370 mm x 486 mm. The Foundation of Weimar Classics.

Page 111: Lena Meyer-Bergner and Hannes Meyer on the beach, *c.* 1931. Photographer: Hannes Meyer (with automatic release). Bauhaus Dessau Foundation.

Page 113: Terrace of the studio building, 2008. Photographer: Astrid Wedemeyer. Archive Prestel Verlag.

Page 114: Curriculum of the New Bauhaus Chicago, *c.* 1938. Bauhaus Archiv Berlin.

Page 115: Hochschule für Gestaltung in Ulm by Max Bill, 1955. Photographer: Ernst Hahn. Bauhaus Archiv Berlin.

Page 116: Herbert Bayer, wall painting in the adjacent stairway (reconstruction) of the main building today at the Bauhaus University in Weimar by Henri van de Velde. Photographer: Hans Engels. Archive Prestel Verlag.

Page 117: *Haus am Horn* by Georg Muche. Photographer: Hans Engels. Archive Prestel Verlag.

Page 118: Photograph of the studio wing of the Bauhaus building by Walter Gropius, 2008. Photographer: Horst Wedemeyer. Archive Prestel Verlag.

Page 119 above: The Kandinsky / Klee master house today by Walter Gropius. HOCHTIEF Aktiengesellschaft/ Wolfgang Kleber.

Page 119 below: Master house ensemble today by Walter Gropius. HOCHTIEF Aktiengesellschaft/ Christoph Schroll.

Page 120: The "new masters' houses" in Dessau of Walter Gropius and László Moholy-Nagy, 2014. Photographer: Doreen Ritzau. Bauhaus Dessau Foundation.

Page 121 above: View into the exhibition space of the Bauhaus Archiv. Photographer: Hans Glave. Bauhaus Archiv Berlin.

Page 121 below: View into the exhibition space of the Bauhaus Archiv. Photographer: Hans Glave. Bauhaus Archiv Berlin.

Page 122: The staircase in Klee's master house today. HOCHTIEF Aktiengesellschaft/ Wolfgang Kleber.

Page 123: The Bauhaus Archiv Berlin by Walter Gropius with Alex Cvijanovic and Hans Brendel. Bauhaus Archiv Berlin.

If you want to know more ...

Hans M. Wingler, *Das Bauhaus. Weimar, Dessau, Berlin 1919–1933*, Joseph Stein 1979. An incomparable wealth of photographs and documents relating to the entire history of the Bauhaus, complemented by informative commentaries by the founder of the Bauhaus Archive, make this book an object to be treasured. A truly definitive work.

A substantial number of lavishly illustrated essays, illuminating almost every corner of Bauhaus history, is offered by this 640-page volume: **Jeannine Fiedler, Peter Feierabend** (eds), *Bauhaus*, Ullmann 2007.

Rainer K. Wick concentrates on the educational concept of the Bauhaus and the various educational approaches of the Bauhaus masters in his detailed book: *Teaching Bauhaus*, Hatje Cantz Publishers 2001.

After the closure of the Bauhaus, many of its members went to America. The paths of these exiles and the influence of the Bauhaus in America from 1933 are traced by this book: **Georg-W. Költsch** et al. (eds), Bauhaus. Dessau–Chicago–New York, DuMont 2000.

A lively and sparkling impression of life at the Bauhaus is given by Oskar Schlemmer's letters, diary entries and other writings, collected in: **Tut Schlemmer** (ed.), *The Letters and Diaries of Oskar Schlemmer*, Northwestern University Press 1990.

Exciting, authentic and continually surprising, the recollections of former Bauhaus members make this book absolutely indispensable for present and future Bauhaus fans: **Eckhard Neumann** (ed.), *Bauhaus and Bauhaus People: Personal Opinions and Recollections of Former Bauhaus Members and Their Contemporaries*, Van Nostrand Reinhold 1970.

The historic paintwork in the Bauhaus building has recently been reconstructed. Now hallways, stairwells and rooms are so radiantly colorful that it takes your breath away. This book shows the results in more than 80 fascinating photographs, complemented by informative basic facts about the Bauhaus: **Kirsten Baumann,** *Bauhaus Dessau: Architecture–Design –Concept*, Jovis 2007.

The Bauhaus directors were all architects, and many colleagues, masters, and students also designed buildings. Many of these buildings are still standing, often right in our midst. This book will appeal to anyone who is curious to know what these buildings look like today: **Ulf Meyer and Hans Engels**, *Bauhaus 1919–1933*, Prestel 2001

Addresses:

Bauhaus-Archiv (Bauhaus Archive)
Museum für Gestaltung
Klingelhöferstr. 14
10785 Berlin
Germany
+49 (0) 30 254 00 20
www.bauhaus.de

Stiftung Bauhaus Dessau (Bauhaus Foundation)
Gropiusallee 38
06846 Dessau-Roßlau
Germany
+49 (0) 340 6508-250
www.bauhaus-dessau.de

Meisterhäuser (Masters' Houses)
Ebertallee 63-71
06846 Dessau-Roßlau
Germany
+49 (0) 340 66 10 934
www. meisterhaeuser.de

Bauhaus-Museum Weimar
Theaterplatz 1
99423 Weimar
Germany
+49 (0) 3643 545-961
www.klassik-stiftung.de

Bauhaus-Universität Weimar
Geschwister-Scholl-Str. 8
99423 Weimar
Germany
+49 (0) 3643 58-0
www.uni-weimar.de
www.gropiuszimmer.de

Haus am Horn
Am Horn 6
99421 Weimar
Germany
www.hausamhorn.de

Website of Bauhaus
institutions in Germany:
www.bauhaus-online.de

Imprint

The pictures in this book were graciously made available by the museums and collections mentioned, or have been taken from the Publisher's archive with exception of:
Bauhaus Archiv Berlin: outside front flap, inside front flap, pp. 5, 6, 8, 9, 10, 11, 12, 13, 15, 18, 19, 21, 22, 23, 24, 26, 32, 33, 34, 35, 36, 37, 38, 40, 41, 42 (right), 43, 44, 45, 46, 47, 52, 53, 54, 55, 56, 58, 59, 60, 61, 63, 64, 67, 70, 71, 72, 73, 74, 77, 79, 82, 84, 85, 86, 87, 89 (right), 90, 92, 93, 94, 95, 96, 99, 101, 102, 105, 107, 108, 109, 114, 115, 121, 123; Bauhaus Dessau Foundation: title page, pp. 30, 65, 75, 76, 111; Galerie Kicken Berlin: outside front flap, pp. 25, 62, 69, 83, 89 (left), 91, 104; Foundation of Weimar Classics: pp. 50, 110; Stadt Dessau-Roßlau, city archives: pp.48 / 49, 120; Städtische Galerie im Lenbachhaus, Munich: p. 51; Archive Erich Consemüller, private collection, Bremen: p. 103; Archive Rudolf Ortner private collection M. Ortner-Bach: p. 68; City of Zurich Stadtarchiv, Archivbestand VII.228. E. Attenhofer, MW. Lenz, Estate: p. 81; Agentur für Bilder zur Zeitgeschichte: p. 97; Photo SCALA, Florence: p. 98; Archive Lempertz (www.lempertz.com): back cover, p. 39; Ketterer Kunst (www.kettererkunst.de): inside front flap, pp.42 (left), 106; Baudenkmal Bundesschule Bernau e.V.: inside front flap, p. 66; Archive of the Tapetenfabrik Rasch: inside front flap, p. 27; Fonds Kandinsky, Bibliothèque Kandinsky, Centre Pompidou, Paris: pp.31, 57, 88; Houghton Libary, Harvard University, Cambridge, Mass: p. 80; Fagus – GreCon: p. 14; Thonet (www.thonet.de): p. 17; Quittenbaum (www.quittenbaum.com): p. 29; HOCHTIEF Aktiengesellschaft: pp.119, 122; © Horst Wedemeyer: front cover.

The publisher has intensely sought to locate all individual artists, and/or institutions who were possibly not able to be contacted and who claim legal rights to illustrated works in this volume are kindly asked to contact the publishing house.

The Library of Congress Control Number: 2015959175
British Library Cataloguing-in-Publication Data: a catalogue record for this book is available from the British Library.

Prestel Verlag
A member of Verlagsgruppe Random House GmbH
Neumarkter Strasse 28 · 81673 Munich

Prestel Publishing Ltd.
14–17 Wells Street
London W1T 3PD

Prestel Publishing
900 Broadway, Suite 603
New York, NY 10003

Translated: Christine Shuttleworth
Project management: Julia Strysio
Editors for the updated new edition: Franziska Neuner and Adeline Henzschel
Editor: Chris Murray
Series editorial and design concept: Sybille Engels, engels zahm + partner
Cover: Benjamin Wolbergs
Layout: Wolfram Söll
Production: Astrid Wedemeyer, Lisa Preissler
Lithography: Repro Ludwig, Zell am See
Printed and bound: Uhl GmbH & Co KG, Radolfzell
Paper: Primaset

Verlagsgruppe Randomhouse FSC®N001967
ISBN 978-3-7913-8210-4
www.prestel.com

The Book Guild Ltd
25 High Street,
Lewes, Sussex

First published 1997

© Anthea Turner and Wendy Turner, 1997

The London Underground logo is the Registered Trade Mark of London Regional Transport and is reproduced with their kind permission

Set in Souvenir Light
Typesetting by Acorn Bookwork, Salisbury, Wilts
Origination, printing and binding in Singapore under the supervision of MRM Graphics Ltd, Winslow, Bucks

A catalogue record for this book is available from the British Library

ISBN 1-85776 238 X

Thank you for coming to our
5th Birthday party
Love Phoebe & Estelle
x x

UNDERNEATH THE UNDERGROUND

BOOK II

by
Anthea Turner
&
Wendy Turner

The Book Guild Ltd
Sussex, England

CONTENTS

Underneath The Underground is dedicated to The Humane Research Trust, a registered charity which raises funds to develop alternative methods to the use of animals in medical research. For further information please write to The Humane Research Trust, 29 Bramhall Lane South, Bramhall, Cheshire, SK7 2DN or telephone 0161 439 8041.

INTRODUCTION

Before you read the *Underneath the Underground* stories, it is important you understand what the London Underground system is all about. As you will know, London is the capital city of England and home to many famous names and places. There are museums, shops, theatres and restaurants. You can walk, take a taxi, or catch a bus to all these things, but what a lot of people in London do is board a train. Now these are not ordinary trains ... they are known as tube trains and they run on a railway network called the London Underground, hidden well away, far below the bustling city streets. Take a look at the Underground map and you will see all the different rail lines, colour coded, and lots of station stops dotted along them. If, one day, you happen to be at any one of these stations, waiting on the platform for a train, you may look down and see a small mouse or two scurrying along the rail track. They might be playing, gathering food, perhaps visiting friends or relatives . . . but as soon as they hear that distant rumble, and then that loud roar as a train speeds into the station, they will quickly and quietly disappear from sight.

So where are they running to? Well, these brave and hardy London mice are heading for the safety of their own world ... Underneath the Underground.

THE COVENT GARDEN CHRISTMAS

Old Grandpa Gardner threw another log on to the fire and turned to face all the mice who had gathered in his front room. Grandpa Gardner lived at Covent Garden Tube Station (Northern Line) and was head of the famous Gardner family. Their skills were in their paws and all week long they beavered away making things for the Covent Garden Mouse Market. Grandpa, however, had long since retired and now he spent a couple of days a week showing visiting mice around the London Transport Museum, which was right in the middle of all the shops and restaurants at Covent Garden.

Little Gary Gardner handed round a dish of nuts and oranges and Grandpa thanked everyone for turning up.

'I also want to thank you,' he said, 'for wanting to make this the biggest and best Christmas we've ever seen on the Underground and for asking me to chair this meeting. Covent Garden is the perfect place to hold all the activities. It's at the very centre of things and everyone can get here quite easily. Now as you know, we've never done much at Christmas on the Underground . . . but all that is about to change! Ladies and gentlemen, it is now the first of December and we must start making plans for Christmas Day immediately!'

'Here, here!' said Arthur Bell of Belsize Park. 'And with that in mind my wife Martha has a very important announcement to make.'

All eyes turned to Martha Bell, who was delighted with the attention.

'As you know,' she said, 'the Really Cheesy Theatre Group are putting on *Cinderella* this Christmas. It's a totally *professional* production, you understand, and I can now reveal that Cinderella will be played by the one and only Sarah Brightmouse!'

All the mice gasped in amazement and little Gary Gardner dropped a dish full of walnuts all over Arthur Bell. The great Sarah Brightmouse! She was a stunningly good-looking mouse, renowned for her singing, and it would be truly marvellous to see her play Cinderella.

'Hold on a minute, Martha,' piped up Tosh Archer of Marble Arch Station. 'How come you know all this?'

Martha blushed and tugged at her whiskers in all the excitement. 'Well, you see . . . I auditioned for the role of Fairy Godmother and it just so happens that I got the part!'

Now the mice were even more shocked and amazed. Martha Bell in a professional pantomime! The first performance was on Christmas Day and they would surely play to a packed audience.

'So we certainly have a first-class pantomime for the little ones to see,' said Grandpa, rubbing his paws together with delight. 'Now, what else are we working on?'

'I've definitely got us a Christmas tree,' said Tosh Archer. 'I've heard from my old friends in Norway and they've organised a lovely big Norwegian pine for us. They'll get it on the ferry and it should be here the day before Christmas Eve. I'm going to get all the youngsters to make the decorations. We'll put it up by the grotto here in Covent Garden and it'll look a treat!'

'The Carol Concert is all set up for Christmas night,' chorused a group of church mice from St Paul's. 'Rehearsals start tomorrow and we'll be practising everyone's favourite Christmas songs.'

5

'What about the presents for the Christmas Grotto?' asked Doris Knight from Knightsbridge Station. 'How are you Covent Garden lot getting on?'

Grandpa Gardner assured Doris that all the Arty Crafty mice who lived at Covent Garden were busy making presents that would be in the grotto on Christmas Day.

'The children won't be disappointed,' said Grandpa. 'I can promise you that on Christmas Day every little mouse on the Underground will have a wonderful present to open . . . and of course there'll be some for us older ones too. No reason why Father Christmouse should forget about us!'

'Oh how I love that story about Father Christmouse,' said Martha Bell. 'Do tell it again,' she asked Grandpa. 'You describe him so well.'

'Father Christmouse is the most beautiful mouse you could ever wish to see,' said Tosh. 'He has white fur as soft as snow and lovely long whiskers. He dresses all in red and wears black boots and a black belt. He lives in the frozen north with lots of elves who help him make Christmas presents. Then, every Christmas Eve, Father Christmouse travels all over the world delivering presents for all the little mice to open on Christmas morning.'

'The children are going to love this Christmas,' said Doris' husband, Vincent Knight. 'And I know the very mouse who can sit in the grotto on Christmas morning and play the part of Father Christmouse. Young Harry is a pure white mouse so it's really got to be him. You remember Harry, don't you?' he chuckled.

All the mice nodded. How could they possibly forget? They'd never seen a white mouse before and when little Nigel Knight introduced him to everyone on the night of

Halloween they all thought they'd seen a ghost! Harry used to live in the Harrods Pet Department in the famous department store but had now made a new life for himself Underneath the Underground.

'Anyway,' continued Vincent, 'I know he's only a young mouse but he's smart and trustworthy and once we've dressed him up properly and padded out the costume he'll suit the part perfectly. He lives at Knightsbridge next to us, so I'll ask him if you like.'

And so the meeting went on. Grandpa brought out some more nuts and Martha produced some home-made mince pies. Eventually, much later that night, all the mice left Covent Garden Station and made their way home. Their minds were racing with thoughts of Cinderella and Carol Concerts, Christmas trees and Christmas presents, and of course Father Christmouse, who lived far away in the frozen north. If everything went according to plan this would be the best Christmas the Underground mice had ever seen!

Two weeks later at the Really Cheesy Theatre Group, Sarah Brightmouse stared at her reflection in the dressing room mirror. She simply couldn't decide which shade of lipstick to wear for her scene in the ballroom with Prince Charming and she called for Martha Bell to help her choose. Martha was still very nervous in the company of the great Sarah Brightmouse and all she could do was assure her that any shade would look fantastic on such a beautiful face.

'Oh you really are too kind, my dear,' said Sarah. 'And don't think that I haven't noticed what a talented actress you are. I'm sure you'll go on to do great things!'

Martha flapped and fluttered about the dressing room and could hardly contain her excitement. She was brought back down to earth by the shouting and yelling of the producer. He wanted *everyone* on the stage and he wanted them there *now*. He was barking orders left, right and centre. The spotlight needed fixing, the ballroom scene needed changing and Prince Charming's trousers were way too tight. Martha sprang to attention and made her way up on to the stage. It was a tough life working in the theatre but *she* was a true professional. Sarah Brightmouse had practically said so! The Christmas Day show was just around the corner and Martha was all set to give the performance of a lifetime.

9

Over at St Paul's Cathedral the church mice were practising 'A Mouse in a Manager'. They lived at St Paul's Tube Station but always practised in the Cathedral itself. This Christmas concert was the biggest thing they had ever done. They sang at church of course every Sunday but this concert on Christmas night demanded something extra special. They were having brand new robes made from purple velvet and every one of them was being careful not to overdo it and strain their voices before the big day.

A mouse in a manger
Was making a nest
So the little Lord Jesus
Could lie down and rest.

Mother Mary sat watching
And Joseph stood by.
Mouse stayed in the manger
'Til morning was nigh.

The baby lay smiling
He stroked mouse's head
And thanked all the creatures
Who had watched by his bed.

The choir master mouse decided that 'A Mouse in a Manger' was the perfect choice for their opening song and now wanted to go on to something else. Two of the sopranos thought they might be coming down with colds and asked if they could leave early. The choir master let them go and prayed that there wouldn't be any sore throats or runny noses on Christmas Day. He needed the full choir in tip-top condition. This was the concert they had all dreamed of performing and nothing but the best would do.

Over at his home in Marble Arch, Tosh Archer was writing to all the young mice on the Underground, asking them to hurry along with the decorations for the tree. Little Elly Archer was busy making long chains out of shiny bottle tops and Uncle Tosh had asked her to make a huge star to go on top of the tree. She was so excited about the beautiful Norwegian pine tree that Uncle Tosh kept on about that she was all fingers and thumbs and the bottle tops kept spinning off across the room. She even had a nightmare about the tree. Last night she'd dreamt that it had started to shed all its needles and by the time Christmas morning came it was quite bald! She picked up a large cardboard cut-out of a star and began covering it with tin-foil from old sweet wrappers. It was time to calm down and get on with the job. Uncle Tosh was going to be proud of her. She was going to make the biggest and brightest star he had *ever* seen!

On the morning of Christmas Eve the whole Underground was buzzing with excitement. The night before had been one of the coldest any of the mice could remember and when they woke up the whole of London was covered with a blanket of snow. It was deep and crisp and so white it almost hurt your eyes to look at it. It was the first snow they'd seen that winter and straight after breakfast all the mice went out to play. They built snowmice and had snowball fights. They did some tobogganing and went ice-skating on frozen puddles. They slipped and fell about and laughed until their sides ached. They were having too much fun to notice how cold it was. Their noses were bright pink and some of them even had icicles on their whiskers.

At Covent Garden in the London Transport Museum, old Grandpa Gardner was taking a break from showing some visiting mice around. He was sitting on the steps of one of the old London buses and was taking large gulps from the steaming hot mug of tea that little Gary had brought over to him. Gary jumped up on to his grandpa's knee and snuggled up close. Gary loved his grandpa. He was his hero and one

day, when he was grown-up, he knew that he would be showing mice around the museum, just like his grandpa did.

'That tea was delicious,' said Grandpa. 'Let's get some more! Harry will be along soon with another sack full of presents for the grotto and I'll bet he'd like a cup.'

Harry, in his role as Father Christmouse, was in full charge of the Christmas Grotto. For the last few days he'd been gathering all the presents that the Covent Garden mice had made, putting them into a sack and taking them off to a secret location. On Christmas morning they would all be laid out in the grotto but until then they had to be kept under lock and key. It was Grandpa Gardner who had suggested the glove box in one of the old London buses at the Transport Museum and it had proved to be a very safe and secret place indeed.

At Covent Garden Station, underneath the Underground, Harry took his sack and made the final collection of presents. The sack was full to the brim and with a final heave he slung it over his shoulder and headed off to meet Grandpa Gardner. How clever they had been, locking away the presents in the glove box of the old bus. No one would ever find out they were there. But that's where Harry was wrong because four little mice were about to do just that! They were the Whitechapel Quads, the naughtiest mice on the London Underground. Their names were Winnie, William, Walter and Wilfred and they were related to the infamous Shadwell Gang from London's East End.

The Whitechapel Quads had already found out that Harry was going to play Father Christmouse and now they were determined to find out where the presents were hidden and see if they could take a few. Laughing and giggling, they scampered after Harry and followed him into the museum. They kept their distance and watched as Harry, Grandpa and Gary proceeded to lock away the presents in the glove box of the bus. Oh what fund they were going to have looking through them all! Winnie wanted to find lots of jewellery and her three bothers dreamt of model cars, boats and planes. They wouldn't take all the presents . . . four big sacks full would be just right!

Harry said goodbye to Grandpa and Gary and set off home. The Whitechapel Quads followed, hoping to steal the key off Harry, but what happened next made them stop dead in their tracks. They stopped laughing too, for what they had just witnessed was no laughing matter. Young Harry had been careless. He had been so excited about the presents and Christmas Day that he hadn't looked where he was going. He'd simply headed straight for the door and run headlong into the path of a human security guard. Quick as a flash the guard bent down and scooped up Harry and told him what a great Christmas present he would make for his little boy.

'My shift doesn't end until four o'clock,' he said. 'So I'll just put you up here in this little box and collect you later!'

The guard put the box high up on to a shelf in a nearby storeroom and walked off, leaving behind a very miserable Harry and the very shocked and frightened Whitechapel Quads.

'Christmas Day will be ruined!' screamed Walter. 'Harry was going to be Father Christmouse and he's got the key to the glove box where all the presents are hidden!'

'Harry's *life* will be ruined,' sniffed Winnie, who had a secret crush on him. 'He belongs here on the Underground, not in somebody's house!'

'We are the only ones who saw what happened,' said William. 'It's down to us. We must save Harry and we must save Christmas Day!'

'I've got an idea,' shouted Wilfred. 'We'll go back to Grandpa Gardner and tell him what we've seen. He's old and wise and will know exactly what to do!'

'Brilliant!' said Winnie, and with that they all ran back to the bus to find Grandpa.

He listened to their story and then stared at them long and hard. The Whitechapel Quads had a very bad reputation for getting up to all kinds of mischief but this time Grandpa really did think that they were telling the truth. Poor Harry was in trouble and Grandpa had to think of a plan to save him. After a few minutes he thought he had the answer and sent Walter to Westminster Station with the following note.

Dear Sir Roger Russell, Young Harry in severe danger at London Transport Museum. Is trapped in box on high shelf. Christmas Day not looking good either. Can't have a Christmas Grotto without Father Christmouse. Alert the Special Mouse Services immediately. It's Harry's only hope! Yours in anticipation, Grandpa Gardner.

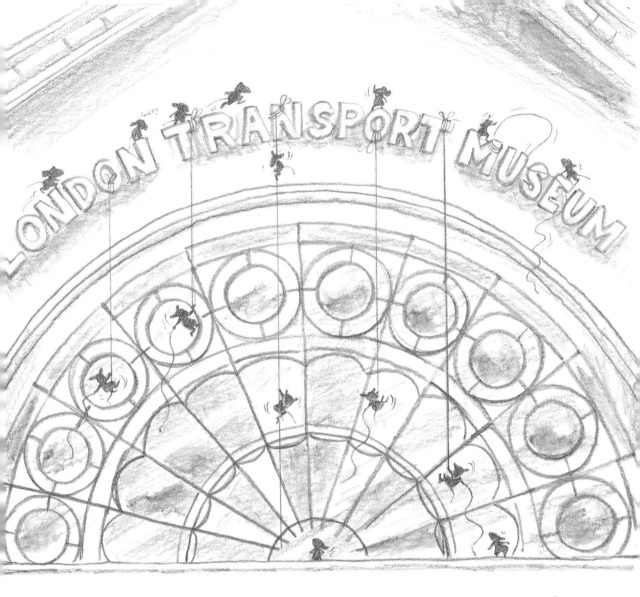

From here on everything happened faster than the speed of light. Walter went to Westminster and Sir Roger called the Special Mouse Services, an elite army of mice who worked for the government, commonly known as the SMS. Within the hour a team of ten jet-black mice arrived at the Transport Museum, carrying ropes and other bits of equipment that would help them climb up and save Harry. In a daring rescue mission they used all their skill and bravery to reach the box that Harry was trapped inside.

21

Far below on the storeroom floor, the Whitechapel Quads, Grandpa and Gary gazed up at all the activity. They clapped and cheered for all they were worth when, eventually, down came one of the SMS mice with a very frightened but relieved Harry clinging on to his back. Harry had been saved and so had Christmas Day and for once the Whitechapel Quads were the heroes of the Underground, not the villains, for without them Harry might have been lost for ever.

On Christmas morning there was a massive queue outside the Christmas Grotto at Covent Garden Tube Station. All the young mice had come for their presents and could hardly believe their eyes when they saw Father Christmouse. He even had two fairies to help him. Elly Archer and Nancy Knight were dressed up in silver outfits with giant wings on their backs. The Norwegian pine tree stood beside the grotto. It was covered in decorations and coloured fairy lights and Tosh Archer was especially pleased with the huge star that took pride of place on top of the tree.

That afternoon *every* mouse who lived on the Underground sat down for the first performance of *Cinderella.* Sarah Brightmouse made a lovely leading lady and Martha Bell acted and sang for all she was worth. Her husband Arthur and their children Billy and Bunty were bursting with pride, and when the cast took their final bow the Bell family clapped and clapped until their paws were sore.

It was much later on, during the interval of the Carol Concert, that Sir Roger Russell thought to ask the Whitechapel Quads why they had been at the London Transport Museum on Christmas Eve. The summer before, they had taken Sir Roger's briefcase while he was having tea on the terrace at the House of Commons. They'd done it as a prank but Sir Roger had not been amused. It had taken all the skill of Charlotte Holmes, the great Baker Street detective mouse, to recover the lost case and as far as Sir Roger was concerned the Whitechapel Quads would always be the naughtiest mice on the Underground.

'So come on, then,' he said. 'What exactly were you doing at the Transport Museum yesterday?'

'It was all those presents!' blurted out Winnie. William and

Wilfred groaned. Big mouth Winnie was about to give the game away but Walter jumped in before she could say any more.

'Yes,' he said. 'We were talking about Christmas presents and it reminded us that we needed extra pocket money to do some last-minute Christmas shopping. So . . . we went to see Grandpa Gardner to see if he had any jobs we could do!'

'Well, well, how kind of you to offer,' said Grandpa, winking at Sir Roger.

Winnie had indeed put her foot in it and he realised now why the Quads had been following Harry.

'It just so happens that I *do* have just the job for you. There's a mountain of scrubbing and cleaning to be done and if you like you can start tomorrow!'

The Whitechapel Quads stared at Grandpa in horror. Scrubbing and cleaning? No thank you! They gathered up their presents, said goodbye and scurried off home as fast as their legs would carry them.

Sir Roger and Grandpa Gardner laughed as they watched them go, then settled down again for the second half of the Carol Concert. Grandpa was still smiling as he looked around at all the other mice. Some of the children were sitting under their seats playing with their new toys. Martha Bell was wearing a fantastic new hat that Arthur had bought for her. Charlotte Holmes was looking seriously pleased with her new magnifying glass and Sarah Brightmouse was obviously delighted with her brand new collection of lipsticks. Grandpa closed his eyes and listened to the music. Their day would soon be over but it would never be forgotten. No one, thought Grandpa, would ever forget the Covent Garden Christmas!

THE TOWER OF LONDON AND THE SPARKLING SUMMER

Martha Bell of Belsize Park (Northern Line) was busy packing her suitcase. In fact she'd been packing it and unpacking it all morning, confused as to what to take with her on holiday and what to leave behind. Now, at last, the job was almost done and with a huge sigh of relief she snapped shut the large, bulging case. Oh how she was looking forward to this family holiday, and the resort she and her husband Arthur had chosen sounded too good to be true! The Waters of Waterloo Station (Northern and Bakerloo Lines) had just finished building a fantastic hotel

there, Underneath the Underground. No expense had been
spared. There was crazy golf for Arthur, beauty treatments
for Martha, a Pirates' Club with lots of fun and games for
their children, Billy and Bunty, and a special courtesy shuttle
service took guests on the underground journey from the
hotel to the sandy beach at Gabriel's Wharf on the banks of
the River Thames.

After polishing his golf clubs, Arthur Bell planned out the
route. It was a long journey but a simple one. All they had to
do was hop on to the footplate of a southbound tube train
and stay there until they reached Waterloo Station.

27

'Billy, Bunty, Martha!' he called. 'Are you nearly ready? We'd better get going soon!'

'Don't rush me Arthur,' shouted Martha, putting on her hat back to front in the race to be ready on time.

'Coming soon, Dad!' shouted Billy and Bunty. They'd never been on a summer holiday before and were showing off their new summer clothes to each other.

'Goodness me,' muttered Arthur, 'if we get to Waterloo Station before midnight it will be a miracle!'

Meanwhile, the Waters family were scurrying around putting all the finishing touches to their hotel. After a long and tiring day, Kate and Bonapart Waters and their son Welly stood together at the hotel entrance waiting for the first guests to arrive. Bonapart Waters looked up with pride at the notice above the door. *'The Waters of Waterloo welcome you to the Hotel Gabriel's Palace'*. It had been hard work for them all but now it seemed worth every moment. It was going to be a long hot summer and everyone who stayed at the hotel was going to have a fantastic time.

On the beach the next morning, on the first day of their holiday, the Bell family were indeed having a wonderful time. Martha was being given a facial, Arthur was winning a game of crazy golf and Billy and Bunty had joined the Pirates' Club. They were in a competition to see who could build the biggest sandcastle and both Billy and Bunty were determined to win.

The Bells weren't the only ones taking advantage of the summer sun and the hotel's luxurious facilities. Martha had already spotted a few familiar faces . . . Connie Conqueror from Tower Hill, Charlotte Holmes, the great Baker Street detective mouse, and Vincent and Doris Knight from Knightsbridge and their children Nigel and Nancy. Martha's brother, Sir Roger Russell, was staying there too with his wife June. Sir Roger lived at Westminster and had a very important job at the Mouse Parliament. He was the Mouse Minister for Transport.

Billy Bell won the sandcastle competition easily and Bunty immediately started to sulk. She wasn't miserable for long though.

'OK all you little pirates,' shouted the club leader, 'now I want to see who can dig the deepest hole on the beach . . . Who will be the first one to dig through to the other side of the world?'

Bunty sprang into action. She hadn't seen the other side of the world before and digging through to it was going to take the best part of the afternoon at least!

It was 20 minutes later when Nigel Knight let out a yell so loud that every mouse on the beach stopped what they were doing and ran over to the large hole that Nigel was now standing in.

'I thought I'd hit some rocks,' said Nigel, 'but look, everyone, it's something gold and sparkling!'

Everyone gasped as they set eyes upon the gold and sparkling thing that Nigel was so excited about. It was half sticking up out of the sand and it looked very much like a jewel-encrusted tiara.

31

'Make way everyone, make way. Let me come past. Stand well back please . . .' Sir Roger Russell was keen to take control of the situation and pushed through the crowd to take a closer look at the discovery. He examined the piece thoroughly and after a few minutes stood up to face the rest of the holiday makers. He was puffed up full of importance and proceeded to make the following speech:

'Anyone who came to this resort expecting a quiet and relaxing holiday must now be prepared for disappointment. Little Nigel Knight has obviously begun to unearth some priceless gems. What you see here is a tiara, ladies and gentlemen . . . without doubt a very real, *diamond* tiara!'

Charlotte Holmes whipped out her magnifying glass and wished that Sir Roger would get on with it so that she could hurry up and take a closer look. Arthur Bell groaned at the thought of his golf being disrupted. Bonapart Waters rubbed his hands together with glee when he thought of all the good publicity this astonishing find would bring to his new hotel. Bunty Bell skipped about and fell into the hole she'd been digging and Connie Conqueror said that she had come over quite faint and needed to find some shade.

Sir Roger continued. 'No more digging can take place here today. This tiara and whatever else may be buried here may be national treasures and I must tell the Heritage Mouse Minister immediately. We must seek her permission to carry on with the dig.'

Sir Roger packed an overnight bag and went to Waterloo Station. He took the Bakerloo Line up to the Embankment and once there he hopped on to a Circle Line train. Just one stop westbound took him to Westminster. Once inside the Houses of Parliament he set about looking for the Heritage Mouse Minister.

As Sir Roger had predicted, the rest of the day was far from relaxing for everyone staying at the Hotel Gabriel's Palace. The hole with the tiara in had to be cordoned off and guarded, the 'little pirates' had to fill in all the other holes, statements had to be made to the police and the Underground newspaper, the *Daily Tail,* wanted quotes from everyone and a huge group photograph.

The Waters family were busy too. Word spread quickly about the hidden treasures buried on the beach and all of a sudden every mouse on the London Underground wanted a room at the Hotel Gabriel's Palace. The roasting heat didn't help. In fact every mouse became so hot and bothered that it was a relief when the sun finally sank below the London skyline and they could all start to cool down.

Bonapart Waters put out lanterns to light up the beach and Vincent and Nigel built a big fire for when it got colder later on. Welly Waters started a barbecue and Kate came around serving home-made lemonade cocktails. Some mice planned to stay and relax for a while and then go up to their hotel rooms. Others had volunteered to stay up all night guarding the treasure, including, to everyone's surprise, Connie Conqueror. Connie lived at Tower Hill Station and was a direct descendent of the mice that came over from France with William the Conqueror back in 1066. She wasn't known for being a brave or hardy mouse and Arthur

36

was amazed when she said that she would stay awake all night and all the next day too if it meant making sure that the treasure was safe.

'But why, Connie?' asked Arthur. 'Surely you're as tired as the rest of us?'

'I am,' admitted Connie, 'but you see, I have a special reason for wanting to make sure that nothing goes wrong . . .'

This had got everyone's attention and Charlotte Holmes demanded that she stop talking in riddles and tell them what was going on.

'All right,' said Connie. 'I wasn't going to say anything until we started to dig again . . . but well, I may know the history of the treasure and how it came to be here.'

'Do get on with it,' urged Charlotte Holmes. Of all the cases she'd dealt with as the Great Baker Street detective mouse, this one was a true mystery and it was driving her crazy!

'Well, I'll tell you a story,' said Connie, 'and then you can judge for yourselves . . . Centuries ago, a beautiful mouse called Mary Conqueror lived at the Tower of London. She was a royal mouse, Princess Mary in fact, but she fell in love with a common mouse known as Cheeky Charlie from Charing Cross. The royal family forbade them to marry and so the two planned to run away. It was midsummer night's eve and a big party was going on in the Tower grounds. When the clock struck midnight, Princess Mary slipped away, dashing from the Tower and scurrying along the banks of the Thames to meet her beloved Cheeky Charlie. To support her and Charlie in their new life together she took with her her collection of precious jewels, including the famous and absolutely priceless Royal Ruby Necklace. But

soon she heard footsteps behind her. The guards were
following hot on her heels and the jewels were getting heavy,
slowing her down. In the distance she could see Cheeky
Charlie waiting for her. The guards were getting closer. It was
Charlie or the jewels and without hesitation she flung the
jewels into the River Thames.

She fled into Charlie's arms as the guards looked into the Thames with horror at seeing the priceless gems disappear. When they looked up, Cheeky Charlie and Princess Mary had gone, vanished into the night. Neither they, nor the jewels, were ever seen or heard of again. The story goes that on *every* midsummer night's eve, the ghost of Princess Mary can be seen running along the banks of the Thames, looking for her lost jewels, *especially* the beautiful Royal Ruby Necklace . . . The trouble is, this is a very old story and no one in my family knows whether any of it is true or not . . .'

All the mice started talking at once but Arthur called for them to be quiet. 'If it is true,' he said, 'and Nigel really *has* found the lost treasure, it's only right that it should go back to the Tower of London with Connie Conqueror, where it belongs. But we mustn't get up our hopes. We'll just have to wait until we get permission to carry on the dig and then see what we find . . .'

And so the night continued. They had food from the barbecue, paddled in the water and sang songs around the fire. Connie Conqueror raised a lantern above the hole that Nigel Knight had dug. The tiara sparkled in the candlelight and she hardly dared think about the many other treasures that may be buried there too.

It was 10.30 the next morning when Sir Roger Russell came running on to the beach waving a piece of paper in his hand.

'Gather round, everyone,' he called. 'I have here some important news ... "Dear Sir Roger, you have official permission from Parliament to continue with the dig. Everyone at Westminster is eager to hear from you as soon as you have finished." '

The mice spent the rest of the morning unearthing precious jewels. The tiara wasn't the only thing buried on the beach at Gabriel's Wharf and they were soon brushing off sand from diamond earrings, an emerald bracelet and a huge sapphire brooch. Every mouse tried to help, from digging in the sand to wheelbarrowing it away, from bringing round cold drinks to wiping beads of sweat off hot faces. Even some French mice joined in. They'd come over from Paris on the Eurostar and couldn't believe what an exciting place London had turned out to be. As time went on they found some more earrings and yet another tiara, but the Royal Ruby Necklace was nowhere to be seen.

DangeR aND biG
WarRings!
~~EXCAF EXGaviTioN~~
~~ECKSCAVAS~~
DiGGiNG
heRe.

Connie Conqueror was devastated. Without the Ruby Necklace how could they be sure that this was the treasure belonging to Princess Mary? Connie was such a romantic mouse that she desperately wanted the tale of Princess Margaret and Cheeky Charlie to be true.

At exactly 1 o'clock, when no mouse felt that he could dig for much longer, Nigel made the discovery that they were all longing for. He held up a necklace, but it was covered in so much sand that they couldn't tell whether it was made of rubies or not. Connie Conqueror and Charlotte Holmes began brushing off the sand and within a few moments Charlotte examined a clean bit with her magnifying glass and declared that it was indeed a very real ruby necklace.

Connie sat on the sand and wept for joy. The jewels hadn't been lost for ever. They were here on the beach at Gabriel's Wharf and soon they would be safe and sound in

the Tower of London. The story was true, and now that the jewels were found, Princess Mary could at last rest in peace.

That night, the Waters family threw a big party in the hotel ballroom. The jewels were on show for all to see and Sir Roger had said it would be all right if the ladies wanted to try on the sparkling gems. The *Daily Tail* photographer took pictures

for the next day's paper and interviewed Connie for a double-page special.

Next morning two ravens flew over from the Tower of London. The Tower was famous for these large and noble birds and they had kindly offered to pick up the jewels from Gabriel's Wharf and fly them back home. All the mice waved as they watched the ravens take off with the jewels in their breaks. When they'd disappeared from sight the mice began to relax. Martha ordered a cocktail and a light massage. Sir Roger started to prepare a speech for the House of Commons and Charlotte Holmes examined some coloured pebbles under her magnifying glass. Bunty Bell wondered whether she wold manage to dig through to the other side of the world before the end of the week and Billy set about making the biggest sandcastle you could possibly imagine.

Arthur Bell picked up his clubs and headed across the beach for a game of crazy golf. He hoped that he would win today, but it really didn't matter if he lost. Nothing, he thought, not even being beaten at crazy golf, could spoil the fact that they were all having the best summer holiday ever!

THE MICE GIRLS LIVE AT WEMBLEY!

Cecil Whitfield finished the letter he was writing to Sir Roger Russell. He marked the envelope 'URGENT' and placed it on the mantelpiece ready to post. His wife Phyllis and their daughters Amanda and Jane were in the kitchen looking through all the cupboards, trying to decide which things to keep and which to let go. With a sinking feeling Cecil realised that when they moved out there was no way they could carry all their belongings with them.

They lived in Staffordshire in the middle of England and it was a long, long way down to London. How Cecil hoped that their new life on the London Underground would be a good one. They didn't want to move, of course, but Cecil and his family and all the other mice who lived down the mines at Whitfield Pit had no choice. The coal mine had closed and very soon the underground tunnels where they lived would be flooded with water. The one hundred mice who had set up home there had to leave or be washed away, and as head mouse at Whitfield it was up to Cecil to lead them all to safety.

He flopped down into his chair by the fire and stared up at the envelope on the mantelpiece. He'd heard such good things about Sir Roger Russell. He lived at Westminster Tube Station and as the Mouse Minister for Transport he had a really important job at the House of Commons. He had a lot of power and commanded a lot of respect and Cecil was absolutely sure that he would help them in their time of trouble.

URGENT!
Sir Roger Russell,
Westminster,
London.
the South.

It was a few days later when Sir Roger received Cecil's letter. He was just about to sit down to a hearty breakfast in the House of Commons restaurant when a postmouse came running in.

'Special delivery for Sir Roger Russell!' he shouted, and explained to Sir Roger that the envelope had a big 'URGENT' written across the front. Sir Roger was starving but curiosity got the better of him and he decided to deal with the letter before tackling his breakfast.

He read it through once and was so upset by it that he completely lost his appetite. He read it through again. This was dreadful news. Whitfield Pit had closed. The mines were

about to be flooded and soon every mouse who lived there would be made homeless. Where would they go? What would they do? They didn't want to go to another coal mine in case that too closed down. Cecil had mentioned the London Underground to the mice at Whitfield, but would they be welcome there? Would they fit in and how could they possibly survive with only the few belongings they could carry with them on the long journey south?

Sir Roger left the restaurant and went into his office. He sat in his huge chair behind his huge desk and began to write a few 'URGENT' letters of his own. He wrote to his closest friends on the Underground and each note said the same thing: 'URGENT! Please attend a meeting tonight at my Westminster home (underneath Platform 3). Whitfield Pit mice are in trouble and we must help. I'll explain everything when we meet. Yours, Sir Roger Russell.'

That night, Arthur and Martha Bell left their home at Belsize Park (Northern Line), shouting goodbye to little Billy and Bunty. Not that they heard them. They had some of their schoolfriends round and were listening to loud music in Bunty's room. Elly Archer was there, along with Kathy Kensington and Nigel and Nancy Knight. They were all dancing around the room and singing along to the songs. They were playing the greatest hits from the Mice Girls, without a doubt the most fantastic pop band on the London Underground!

When they were too tired to dance any longer they sat down on the floor and talked about their favourite group.

'I like Ginger Mice Girl the best!' declared Elly Archer, wondering if she dared to dye a bit of her fur a bright ginger colour.

'Oh no, Sporty Mice Girl is much nicer!' argued Kathy Kensington, wondering what her mother would say if she dared to wear clothes like the ones her favourite singer wore.

'Well, I think they're ALL beautiful,' said Nigel Knight, and blushed terribly for the rest of the night, while the others teased him for being in love with all five Mice Girls.

Meanwhile, over at Sir Roger Russell's house, the evening was a far more serious affair. Sir Roger had explained the situation of the Whitfield Pit mice and was not looking at a sea of horrified faces.

'Oh those poor mice,' wailed Doris Knight from Knightsbridge Tube Station. 'We must do something. Think, Sir Roger, think!'

'I *am* thinking, Doris,' he said. 'We must all put on our thinking caps and see what we can come up with. The Pit mice are welcome here, there's no doubt about that. But remember, there'll be one hundred of them arriving with nowhere to go, no food and not too many belongings. We must offer practical help. Those mice are in trouble and I hereby declare a full state of emergency!'

The meeting was now in full swing and everyone there came forward with suggestions and plans. All the mice on the Underground had to be encouraged to help and Martha Bell suggested that it would be a nice idea to give the Pit mice some kind of welcoming party to lift their spirits when they arrived.

'How about a game of golf?' said Arthur, who was keen on the subject.

'A garden party at the Tower of London?' suggested Connie Conqueror.

'A treasure hunt?' said Charlotte Holmes, the great Baker Street detective mouse.

'How about a stage play?' ventured Martha Bell, fancying herself in the leading role.

'No, no, no!' said Caron Kensington from South Kensington Tube Station. 'I'm sorry but you're all being just too boring for words! We need something big, something dazzling! We need dancing and music . . . We need the Mice Girls!'

The whole room went silent while everyone stared at Caron Kensington. The Mice Girls? Was she *mad*? They were huge, massive, famous! Would they *possibly* consider putting on some kind of concert to welcome the Pit mice? Sir Roger Russell's heart began pounding as he realised that Caron was right, they needed to do something really spectacular!

'This could work,' he said slowly. 'But any mouse on the London Underground who wants a ticket to the concert will

have to give something to the Pit mice in return . . .'

'Like a piece of clothing,' said Doris. 'Or a pot of jam and a loaf of bread.'

'Exactly!' said Sir Roger. 'And everyone will have to chip in and put them up for a while too. There's plenty of room on the Underground but they should stay with us until they get settled in properly.'

'So that's it,' said Arthur Bell. 'Anything that anyone can do to help will buy them a ticket to see the Mice Girls live in concert! But it's all very well talking about it. Where do we go from here?'

'There's only one person who can organise such a huge pop concert,' said Caron Kensington, who seemed to know all about this kind of thing.

'And that's the one and only Harvey Goldmouse!'

'Very well,' said Sir Roger. 'I'll meet him tomorrow!'

But Harvey Goldmouse was very powerful and extremely busy and it was three days before Sir Roger could arrange a meeting. Harvey arranged lots of concerts but nevertheless seemed genuinely excited about Sir Roger's proposal. He'd even asked two experts to join them in the meeting, Bob and Midge. They were songwriters and had organised a similar 'charity' concert in the past.

Now Harvey Goldmouse was sitting back in his chair, sucking a large lollipop and suggesting that Bob and Midge write a special song for the Mice Girls to sing for the Whitfield Pit mice. Harvey had spoken to the Mice Girls the night before and they'd agreed straightaway to do the concert. So that was that. A date was set and hundreds of posters were put up all over the Underground . . . 'A concert in aid of the Whitfield Pit mice. Don't miss it! The Mice Girls Live at Wembley!'

Back at Whitfield Pit, Cecil stared at the poster that Sir Roger had sent to him. He still couldn't believe his eyes! Phyllis had burst into tears when she found out how kind the London mice were being and little Amanda and Jane could hardly sit still for two seconds at the thought of seeing the Mice Girls. Now, the move down south didn't seem so bad after all, in fact some of the Whitfield mice said they were really excited about going and even looking forward to it! Cecil stuck the poster to the wall. Just one week to go and then they'd be off. He hardly dared to think about it. His family had lived down the mines for years and years and now it was all coming to an end. But he was a strong mouse! A brave mouse! He wouldn't cry and he wouldn't look back. He'd put his best paw forward and head south. It would be an adventure. Yes, that was it, a true adventure, and perhaps,

→ TO HAM

if he tried hard enough, he could look forward to it too.

With just a few days to go to the concert every single mouse on the Underground was working hard to get a ticket. Some were making clothes and others were making up huge hampers of food for the Pit mice. Billy and Bunty donated some of their toys and Vincent Knight had just finished carving a set of wooden chairs. Caron Kensington was busy making hats and mittens for the little ones but had taken a break from her work to do an interview with the Underground newspaper, the *Daily Tail.* The Showbiz Editor was famous for his gossip page. He was known as the Mighty Morgan Mouse and he always had a good nose for a story. The Mice Girls Live at Wembley was the story of the year and he was sitting in Caron's living room getting quotes from her about the concert.

Sir Roger had organised some storage space at Wembley Tube Station and in no time at all the large room was heaving with food and clothes and furniture for the Pit mice. Every day the mice would scurry to and fro with boxes of stuff, every one of them, even the older ones, totally caught in the excitement of seeing the Mice Girls.

'Oh that Posh Mice Girl is so outrageous!' giggled Doris

Knight, wishing that she too had the confidence to be so outspoken.

'Not as bad as the Scary Mice Girl,' replied Martha Bell. 'I wonder if a pair of glasses would suit me. . . .'

'What about the Baby Mice Girl?' shouted Caron Kensington. 'She's my favourite . . . she's such a terrific dancer!'

The morning of the concert dawned bright and clear, not just in London but also in Staffordshire as well. The Whitfield Pit mice were ready to leave and when they walked outside the bright sunlight made them screw up their eyes. They lived in the dark mines deep underground and this fierce light would take some getting used to! Cecil, however, was already used to it, for he had been up every morning for a week, planning their journey to Stoke-on-Trent Railway Station. Cecil had been following several people who left for work at the same time every morning and eventually he had found someone who always went to the station. He had jumped up on to the car wheel axle and now all the other mice must do the same. The train from Stoke-on-Trent

would take them straight down to London's Euston Station and from here they would go to Wembley.

The Mice Girls concert was to take place at Wembley Arena. A huge amount of famous people bands played there but the mice had set up their own arena underneath the stage. Harvey Goldmouse sat in a front row seat and listened to the Mice Girls practise their opening number. It was the song that Bob and Midge had written for them and it was destined to go into the charts at number one! Harvey looked at his watch. The doors would open in exactly an hour's time and in all his years in the business he realised that he had never looked forward to a concert as much as this one.

And he wasn't the only mouse on the Underground with such thoughts. By the time the doors opened the shouting and screaming was quite deafening and all the mice had to hold on to their tails firmly to avoid getting them trampled on. The Pit mice had finally arrived, tired and exhausted but as keen as every other mouse to find their seats. And what good seats they were too! As guests of honour they were on the front two rows. Connie Conqueror of Tower Hill was sitting at the front too. She was of royal descent and had given the concert her royal seal of approval.

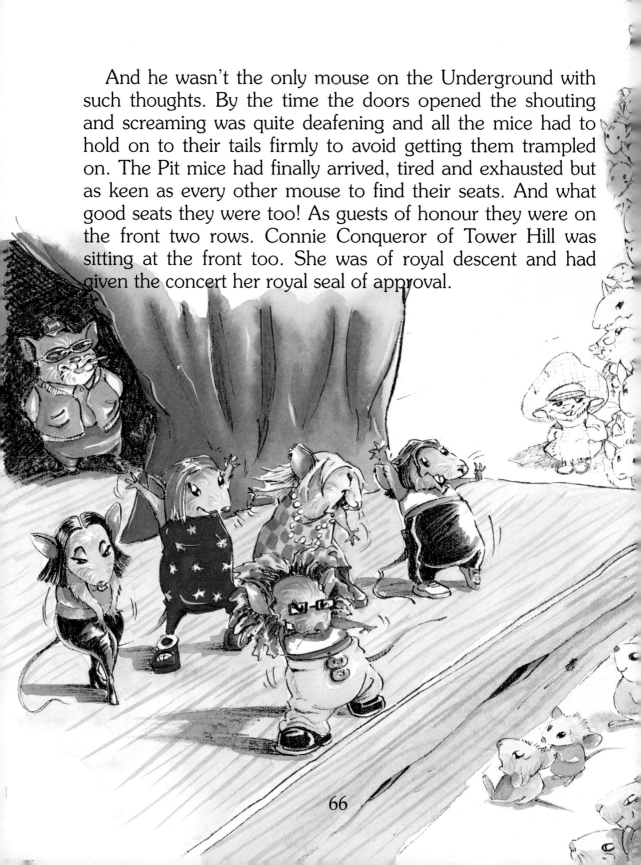

66

When the Mice Girls ran on to the stage everyone stood up and cheered. Ginger, Sporty, Posh, Scary and Baby strutted about and pouted at the audience and everyone loved them! Harvey Goldmouse was walking round as please as punch and all the mice with enough energy were dancing in the aisles. Bob and Midge were delighted with the song they'd written and the Mighty Morgan Mouse asked them for an exclusive interview for the *Daily Tail*. Sir Roger Russell mopped his brow. He was hot and sticky but having a great time and he'd even decided to go out the next day and get a copy of the *Mice Girls' Greatest Hits*!

Much later on when it was all over, all the mice made their way to Wembley Tube Station. The Mice Girls came too and helped to give out all the things that the Underground mice had made or donated to the Pit mice. With tears in his eyes Cecil shook Sir Roger's hand and thanked him from the bottom of his heart for all his help.

'We may have lost our homes,' he said, 'but we have found some true friends!'

The next day the *Daily Tail* had devoted four whole pages to the concert. There were colour photographs, exclusive interviews and plenty of gossip on the Mighty Morgan Mouse's showbiz page. Every mouse on the Underground read the paper that morning and every single one of them agreed with the front page headline:

'BEST NIGHT OUT IN YEARS — MAY THE MICE GIRLS
SING FOR EVER!'

Cecil put down the newspaper. He had a good feeling about the London Underground and when Phyllis, Amanda and Jane came running in with huge smiles on their faces, waving Mice Girl posters and chatting about their new friends, he knew that life here was going to be just perfect!

THE SCARY HAIRY CREATURE AT KEW GARDENS

Rusty the caterpillar was sitting alongside the train tracks at South Kensington Tube Station (District Line) going over once more the events that had led to him being there. The day had started badly. He woke up as usual in the garden of number 27 Onslow Gardens and began eating his breakfast – one whole nettle leaf. Halfway through he decided that today he would try something different. He nibbled on a rose leaf but it tasted so horrible that he spat it out straightaway. He was about to make his way over to the nettle patch when two great human hands cut the rose stem and added the flower, and him, to a large bouquet.

Later on, this bunch of colourful flowers was given to a lady who worked in an office in South Kensington. She was leaving to go to another job in the city. At 5 o'clock she waved goodbye to her workmates, picked up her flowers and made her way to South Kensington Tube Station. There was a huge roar as the train came in, then lots of shoving and pushing as people tried to squeeze on. The flowers were shaking about in all directions and Rusty felt himself falling through the air. The next thing he knew he was sitting by the side of the tracks watching the tube train disappear into the distance.

And so here he was on the London Underground. There was no blue sky above him and worst of all there wasn't a nettle patch in sight! More people came piling on to the platform. 'I wish I was on a nettle leaf,' sniffed Rusty. 'Even a rose leaf would be nice . . .' Poor Rusty. He didn't know where to go or what to do.

Elly Archer got ready to jump off the footplate of the tube train she'd been travelling on, realising they would soon be stopping at South Kensington. She'd come all the way from her home at Marble Arch (Central Line) and this was the first time that her parents had given her permission to travel on her own. She met up with her best friend, Kathy Kensington, and they giggled loudly as they

made their way along the tracks towards Kathy's home. In a split second they were shocked into silence. They'd seen Rusty, Rusty had seen them and all at once the three of them opened their mouths and shouted out in terror.

'Please don't eat me!' cried Rusty, fearing the worst.

'It's a scary hairy creature!' screamed Elly Archer, and flung herself on to Kathy, who was too frightened to say anything.

Rusty was furious! A scary hairy creature? He'd never been so insulted in all his short life. No one, not even these fearsome furry creatures, were going to get away with calling him names like that! 'Indeed I am *not* a scary hairy creature!' he said, arching his body so that all the little hairs on his back stood up on end. 'My name's Rusty and I'm a caterpillar. I may not look much now, I know, but one day I'm going to be a beautiful Red Admiral butterfly, just like my mum, with wings so big and strong that I'll be able to fly all over London!'

Kathy and Elly still thought he looked like a monster and ran off to get Kathy's mum and dad, Kenny and Caron Kensington. When they saw Rusty they too thought he looked very much like a scary hairy creature and once again Rusty had to explain himself. The mice introduced themselves and nodded politely as Rusty went on and on about the Red Admiral butterfly. They didn't really believe him. How could this be true? How could this ugly, scary hairy creature one day turn into a beautiful Red Admiral butterfly? And anyway, what exactly was a Red Admiral butterfly?

Lots of questions needed to be answered but Kenny Kensington knew one thing for certain – Rusty, scary hairy creature or not, didn't belong here on the London Underground. None of them knew what to do until Caron had a very bright idea. 'Let's take Rusty to the Natural History Museum! They have all kinds of creepy-crawlies there. They'll know what to do for the best.'

'Creepy-crawlies,' muttered Rusty under his breath. 'These mice know absolutely nothing.' He thought he may as well go along with the idea, though . . . anything to get out of this dark place where trains came rushing over your head every few minutes.

'We'll go to the museum straightaway then,' said Kenny, and all the mice started running along the track.

'Come on, Rusty,' called Elly. But after just a few yards they all looked back to see that Rusty had barely moved an inch.

'Caterpillars don't run,' shouted Rusty. 'We crawl and we go very carefully and very slowly.'

The mice ran back to him and Kenny realised that without some kind of help it would take Rusty several days to make the journey from the tube station to the museum.

'Vincent Knight,' said Caron with yet another bright idea. 'He's a cabinet-maker, you know . . . makes lots of furniture and does all those nice wood carvings. I bet he could make us a wooden trolley that Rusty could sit in and we could pull behind us!'

'Good thinking, my dear,' said Kenny, and he sent Elly and Kathy to Knightsbridge to find Vincent Knight.

'Come home with us for a while,' said Caron to Rusty. 'We only live just below here and we can't very well stay by the tracks all evening.'

'Why not?' thought Rusty gloomily. He didn't like the

thought of going even deeper underground. Where they were at the moment was bad enough. Still, they were trying to be helpful so he accepted Caron's invitation.

It took Rusty ages to reach their home, underneath the underground and once there he flopped out on to the settee. Caron set about making them all some hot soup and toast for supper and Rusty hoped that it was nettle soup and not some recipe using rose leaves. It turned out to be carrot soup. Rusty had never tasted carrots before. It was all right but oh how he longed for a juicy patch of nettles!

It was quite late by the time Elly and Kathy got back from Knightsbridge and Rusty had long since resigned himself to the fact that he was going to be spending the night at South Kensington Tube Station. Luckily, Elly and Kathy had found Vincent Knight at home, and after they explained the

situation he agreed to make a trolley for Rusty. Elly said that it was very urgent so Vincent said that he would work through the night and deliver the trolley to them the next morning. Vincent had waved goodbye to the girls and scurried back into the house to tell the story to his wife Doris. A scary hairy creature on the Underground! And one that was going to turn into a beautiful butterfly, whatever that was. If this was a big joke there was going to be very big trouble!

Rusty slept all night on the settee and was the first to hear Vincent Knight hammering on the front door the next morning. Rusty started crawling towards the door but all the mice beat him to it. Vincent stopped and stared when he saw Rusty. So it wasn't a joke. There really was a scary hairy creature on the London Underground. Just wait until he got home and told Doris!

'Come on, Rusty old chap,' said Kenny Kensington. 'Get into the trolley and we'll get going to the Natural History Museum.'

Vincent headed off home and the Kensingtons made their way to the museum, pulling Rusty behind them. The trolley was a big success and it didn't take them long to reach the museum entrance. Crossing over the Cromwell Road had been a bit scary though. The mice had run so fast that Rusty thought he might bounce right out and fall flat on his face.

Kenny told their story to the security mouse on duty and asked him to tell the head curator mouse that they were here. The security mouse went away to find the boss and within half a minute a mouse wearing a very smart suit and tie came running over to them.

'You've got a caterpillar... going to be a Red Admiral, you say? What a rare treat this is!'

The mice were shocked. Perhaps Rusty was something special after all. The curator mouse led them to the library and told them everything they needed to know. He said that Red Admirals were becoming quite rare because humans were destroying the land and the plants that Red Admirals needed to survive. There were more buildings for the humans but that meant less land and food for caterpillars like Rusty. He then told them that a caterpillar turns into something called a chrysalis.

'He makes a sort of coat in which he wraps himself and he can't see or speak to anyone for seventeen days. After this he emerges, transformed into a beautiful butterfly.'

He reached on to the shelf for a book and the mice gasped in amazement when they saw a picture of a Red Admiral. It was a truly beautiful creature.

'That's my mum!' cried Rusty, and he had to fight back the tears as he told the mice about his kind and gentle mother. She'd flown away to South Africa because she couldn't stand the cold of a British winter, he explained. She was a very strong flier. She had made him a solemn promise that she would come back for him when he had grown up and she would take him to Africa with her. Rusty dabbed his eyes with one of his legs.

'What do we do now?' asked Kenny. 'It sounds as if Rusty needs the very best care and attention!'

RED ADMIRAL.
VANESSA ATLANTA

The curator mouse told them that they should take Rusty to the biggest and best place for a butterfly in the whole of London. They must take him to Kew Gardens and they must take him today.

And so back they all went to South Kensington Tube Station, where they took the District Line westbound to Kew Gardens. It was late afternoon by the time they reached the main gates of the gardens. They demanded to see the mice in charge and soon they were shaking hands with Brian and Bert Kew, the two Head Gardeners, and their wives Millicent and Jean, responsible for morning coffee and afternoon teas. They were delighted to have Rusty at Kew and decided that the best place for him would be the Scented Garden.

Millicent and Jean assured him that they would bring him plenty of nettles to much on at every mealtime and Jean even promised him that she'd have a go at making some nettle soup!

Rusty perched on a lavender bush in the Scented Garden while he said goodbye in turn to all the mice who'd helped him get here. Elly and Kathy were nearly in tears at the thought of leaving Rusty, but Brian and Bert assured them that when the time was right they would send word that Rusty the Red Admiral was about to come out of his chrysalis, then all the mice could come and see him again.

'Oh no!' cried Rusty. 'What about my mum? She left me at number twenty-seven Onslow Gardens. She could be home any day now and she won't be able to find me!'

'Now don't worry about a thing, Rusty,' said Kenny. 'Caron and I will visit number twenty-seven every day and keep a lookout for your mum. We'll tell her where you are and she can fly over here to see you.'

So everything had been sorted out. The mice made their way back home and Rusty began to relax and take in his new surroundings. Brian and Bert started to discuss a new variety of alpine plant they'd discovered and Millicent and Jean went off in search of nettles. Hours later, when darkness finally fell over Kew Gardens, Rusty dozed off to sleep, dreaming of nothing but becoming a Red Admiral butterfly.

Three weeks later, one bright and sunny morning, the excitement in the Scented Garden was almost too much to bear. The story of the scary hairy creature had spread in no time and every mouse on the London Underground had come over to see Rusty turn into a butterfly. The *Daily Tail* newspaper wanted to do a full-colour feature on Rusty and the photographer could hardly wait to get snapping. Rusty's mother was there, fluttering about from flower to flower, and Martha Bell from Belsize Park had very thoughtfully brought a mirror with her, to show Rusty how big and colourful he was.

When Rusty's wings finally unfolded all the mice clapped and cheered. He wasn't a scary hairy creature any more. He was without doubt a *very very beautiful* Red Admiral butterfly.